THE HOUSTORIAN DICTIONARY

DICTIONARY

• AN INSIDER'S INDEX TO HOUSTON •

JAMES GLASSMAN

THE
History
PRESS

Published by The History Press
Charleston, SC 29403
www.historypress.net

Copyright © 2015 by James Glassman
All rights reserved

Front and back cover maps courtesy of the Library of Congress,
Geography and Map Division.

All images courtesy of James Glassman.

First published 2015

Manufactured in the United States

ISBN 978.1.46711.800.2

For Helen Baernstein, who loved books.

CONTENTS

Acknowledgements 7

Introduction 9

Houston A to Z 11

Appendix: Numbers, Figures, Digits and Dates 185

About the Author 189

ACKNOWLEDGEMENTS

I am indebted to my parents, Elene Glassman and Mitchell Glassman, for providing me with a loving home and a first-class education and instilling in me curiosity and a love of words. They also knew when to leave me alone to tinker.

In 1990, the first edition of Stephen Fox's *Houston Architectural Guide* was published. To put it simply, this book changed everything for me. As a college undergraduate, majoring in history, I was on the verge of deciding a career. While I knew a liberal arts education was the best foundation for the rest of my life, I didn't know what that might be or how to get there. *The Houston Architectural Guide* showed me my hometown filled with good and bad architecture, but most importantly, it showed me history—so much history! There was so much worth knowing about and so much worth saving, too. Yes, as Stephen said so eloquently, "Amnesia is an essential local cultural attribute." Well, I don't think it needs to be that way! I am committed to curing this amnesia through my preservation group Houstorian. I encourage you to buy his book—it has meant so much to me, and I hope it will mean something to you, too.

I was also inspired by John Schwartz's 1987 documentary film *This Is Our Home, It Is Not for Sale*. This thorough history of Houston's Riverside Terrace showed me that my hometown had stories worth telling. It's not easy to find a copy, but it's worth the effort.

I would also like to thank the following mentors: Ginny Roeder, Elsie and Orson Cook, Patrick Peters and Barry Moore, all of whom showed me ways to discover Houston history and the joy in preserving history.

ACKNOWLEDGEMENTS

Thank you to Cory van der Does, Missy Wibbelsman, Anne Leader Guether, Caroline Starry LeBlanc and Jared LeBlanc, Patricia and Lawrence Curry, Andrew Curry, Pete Gershon and Donna Scott.

And thank you to my brother, Peter Glassman, and his wife, Erica Gunderson, and also to my sister, Hilary Reagin, and her husband, Kevin Reagin.

INTRODUCTION

Welcome to Houston! I mean that for everyone, from natives to Newstonians. While we all know at least a little something about the largest city in Texas, no one knows everything about Houston, its history, people, events, landmarks and slang. *The Houstorian Dictionary* is an attempt to make everyone an expert. Even though we've always been a forward-looking community since our founding in 1836, the past remains alive in our customs, expressions and dreams, even if most of us don't realize it. *The Houstorian Dictionary* shows how all of us are connected to one another, not simply from the city's history, but also because of the things that brought us here and the things that keep us here. Each entry connects to another, drawing a composite picture of Magnolia City/ Bayou City/Space City/Clutch City/Sprawl City. This work describes the innovators, artists, heroes, hucksters, scientists, philanthropists, performers, politicians and tinkerers who share the unique Houston DNA. It also provides backgrounds for the novels, movies, songs and quotations that make Houston so endeared to the rest of the world. I've also drawn a few illustrations and scattered them throughout.

The Houstorian Dictionary is by no means comprehensive—Houston grows too fast to be able to capture it all. Please pardon me if I left out something important.

This is a project from the preservation group Houstorian, which I founded in 2006 in response to Houston's history problem. Yes, Houston has history, but we have a lousy record for preserving it. The history is

here—we just don't remember it like we should. Houstorian's mission is nothing short of changing the way we look at ourselves and our city. Ultimately, Houstorian is about telling the story of Houston.

Please enjoy.

Oh, and Save the Dome!

HOUSTON A TO Z

A&M
Shortened version of TEXAS A&M UNIVERSITY in COLLEGE STATION, Texas.

ACRES HOMES
Small community in Northwest Houston, founded in the 1940s and predominantly African American. The City of Houston began incorporating it in the 1960s. Also known as "the 44," from the bus route there.

ADAIR, RED
(1915–2004)
Native Houstonian and world-renowned oil well firefighter and offshore oil rig blowout capping specialist from 1959 to 1993. John Wayne played him in the 1968 movie *Hellfighters* with all of the requisite Houston swagger.

ADAMS, BUD
(1923–2013)
Combative and unloved HOUSTON OILERS' owner who co-founded the American Football Conference. In the late 1980s, he coerced HARRIS COUNTY into removing the beloved ASTRODOME scoreboard in favor of more seats. A few years later, he moved the team to Tennessee and renamed them the Titans.

ADDICKS RESERVOIR
A flood prevention project along the Addicks Dam, at the head of BUFFALO BAYOU, west of Houston. Named for nearby former town of Addicks. Authorized in 1938 with the BARKER RESERVOIR. A popular site for runners and coyotes.

ADICKES, DAVID
(1928–present)
Painter, sculptor and socialite who made "BIG SAM," the sixty-seven-foot statue of SAM HOUSTON in HUNTSVILLE; *BIG ALEX* in MONTROSE; and the PRESIDENTS HEADS series.

AD PLAYERS
The After Dinner Players acting company, founded by Jeannette Clift George in 1967. It moved into the Grace Theater on West Alabama in the 1970s and is known for plays about hope and faith.

AEROSOL WARFARE
Video magazine, spray painting artists' group project and studio founded in 1990 by GONZO247 and MERGE360 and located in EADO.

AEROS, THE
Houston's former American Hockey League team, founded in 1994; they never really took flight. Named for Houston's World Hockey Association team in the 1970s. Sold to Des Moines in 2013.

AGGIE
The mascot or a person who attends TEXAS A&M. From the school's formal name, Texas Agricultural and Mechanical. Former butt of so-called Aggie jokes, but those have faded with time. Typically a more politically conservative person.

"A-HAW-HAW-HAW-HAW"
Bluesy, ZZ TOP refrain from the song "LA GRANGE," borrowed from John Lee Hooker.

AKEEM
English misspelling of HAKEEM OLAJUWON, corrected in the late 1980s. Known then as "Akeem the Dream."

AN INSIDER'S INDEX TO HOUSTON

ALABAMA-COUSHATTA
An American Indian tribe in nearby Livingston, Texas. Their casino is two and a half hours by car, in Kinder, Louisiana.

ALABAMA THEATRE
A former single-screen Art Deco movie house that opened in 1939. It showed first-run films until the early 1980s. Austin-based book retailer Bookstop restored the building, preserving its distinctive architecture, but in the 2000s, landlord WEINGARTEN opted to remove the beautiful interior and simplify the space to attract a tenant. Also known for its landmark curbside vertical sign that can be seen along Shepherd Drive. The current occupant is a Trader Joe's.

ALBEE, EDWARD
(1928–present)
Multiple Pulitzer Prize–winning playwright who taught at UNIVERSITY OF HOUSTON's School of Theatre and Dance from 1989 to 2003 and again in 2010.

ALBERT THOMAS CONVENTION CENTER
Former Downtown, multi-block convention center named for the former local congressman ALBERT THOMAS, opened in 1967. Now known as the BAYOU PLACE entertainment complex, the location of Bayou Music Center, Hard Rock Café and Sundance Cinemas.

ALDINE
Unincorporated collection of low-income neighborhoods north of Houston, within HARRIS COUNTY.

ALEXANDER, JOHN
(1945–present)
Beaumont-born visual artist. Taught at UNIVERSITY OF HOUSTON in the 1970s. Represented locally by McClain Gallery.

ALI, MUHAMMAD
(1942–present)
Olympic gold medal winner and World Heavyweight Championship boxer from Louisville, Kentucky. He won four matches in the ASTRODOME. In 1967, he refused induction into the U.S. Army, was arrested and was sentenced following a conviction, all in Houston. The U.S. Supreme Court later overturned the conviction.

ALLEN, AUGUSTUS
(1806–1864)
New York land developer who moved with his brother, JOHN KIRBY ALLEN, to Texas in 1832. The ALLEN BROTHERS bought 6,642 acres at the confluence of BUFFALO BAYOU and WHITE OAK BAYOU, at the highest navigable point, in 1836 and advertised in the *TELEGRAPH AND TEXAS REGISTER* for their new speculative venture. Shrewdly named it after the hero of the BATTLE OF SAN JACINTO, SAM HOUSTON. Married and later separated from CHARLOTTE ALLEN. THE ALLEN BROTHERS supplied the REPUBLIC OF TEXAS with the first capitol building.

ALLEN BROTHERS
Ambitious New York land speculators AUGUSTUS ALLEN and JOHN KIRBY ALLEN.

ALLEN, CHARLOTTE
(1805–1895)
Wife of Houston co-founder AUGUSTUS ALLEN. She was an early settler to Houston and remained in Houston following her separation from Augustus. She donated the land that became MARKET SQUARE. She is buried in GLENWOOD CEMETERY and is known as THE MOTHER OF HOUSTON.

ALLEN, DEBBIE
(1950–present)
Dancer, choreographer, actor, director and movie producer born and raised in Houston. Sister of PHYLICIA RASHĀD.

ALLEN, JOHN KIRBY
(1810–1838)
New York land developer who moved with his brother, AUGUSTUS ALLEN, to Texas is 1832. The ALLEN BROTHERS bought 6,642 acres at the confluence of BUFFALO BAYOU and WHITE OAK BAYOU, at the highest navigable point, in 1836 and advertised in the *TELEGRAPH AND TEXAS REGISTER* for their new speculative venture. Shrewdly named it after the hero of the BATTLE OF SAN JACINTO, SAM HOUSTON. The ALLEN BROTHERS supplied the REPUBLIC OF TEXAS with the first capitol building. Served as a congressman from Nacogdoches in the Texas Congress. Buried in FOUNDERS MEMORIAL CEMETERY.

ALLEN PARKWAY
A signature Houston public park and street along BUFFALO BAYOU from
Shepherd Drive to Downtown. A quick connector from RIVER OAKS and
NEARTOWN to Downtown. Site of the ART CAR PARADE, the FREE PRESS
SUMMER FEST, Fourth of July celebrations and the final leg of the annual
marathon. Extensive updates including bridges, signage, lighting, pocket
parks and landscaping began in 2010.

ALLEN'S LANDING
Site at the confluence of BUFFALO BAYOU and WHITE OAK BAYOU where
the ALLEN BROTHERS founded Houston in 1836. The head of navigation
for vessels coming up from GALVESTON BAY. Formerly the first PORT OF
HOUSTON, where ships, trains and wagons converged.

ALLEY THEATRE, THE
Nonprofit professional theater in Downtown Houston, founded in 1947 by
Nina Vance. Won a Tony Award in 1996.

"ALL HAT, NO CATTLE"
A phrase for someone who exaggerates or pretends to be something he is not.

ALLIGATOR
Spanish explorers dubbed the native reptile *el lagarto*, or the lizard, which was
anglicized into "alligator." Sightings increase in the late spring in the coastal
wetlands and occasionally near a bayou.

ALLISON
A slow-moving but powerful TROPICAL STORM in June 2001 that caused
catastrophic flooding in Houston, especially in the tunnels and basements
of Downtown and the MEDICAL CENTER. Portions of below-grade
SOUTHWEST FREEWAY in NEARTOWN that were being rebuilt became lakes
for several days. Allison was responsible for forty-one deaths and more
than $5 billion in damages.

ALL Y'ALL
Slang, the most inclusive version of "Y'ALL." Used for emphasis in a large group.

AMERICAN GENERAL CORPORATION
Fire and casualty insurance company founded in 1926 as American General Insurance Company by GUS WORTHAM and John Link. Parent company of American General Life Insurance Company and one of the largest insurance and financial services companies in the United States when it was acquired by AIG in 2001.

AMNESIA
Pervasive local ailment afflicting Houstonians and leading to their lack of regard for history. Coined by architectural historian STEPHEN FOX in his 1990s *HOUSTON ARCHITECTURAL GUIDE*.

ANCHOR TENANT
Typically the major retail store in a strip mall or shopping mall, attracting smaller tenants and the public.

ANDERSON FAIR
Anderson Fair Retail Restaurant and Blue Squirrel Theater is a landmark neighborhood coffee house/restaurant/live music venue in MONTROSE, known for long-hairs and singer/songwriters since the 1960s. Founded by Marvin Anderson and Gray Fair. Beware of the shushers in the audience.

ANDERSON, M.D. (MONROE DUNAWAY)
(1873–1939)
With WILL CLAYTON, he was a co-founder of Anderson, Clayton and Company, the world's largest COTTON trading company, which moved to Houston in 1916. His M.D. Anderson Foundation was a major contributor to the MED CENTER.

ANDERSON, WES
(1969–present)
Native Houstonian and filmmaker who co-wrote and directed the movie RUSHMORE, shot in Houston, and the Oscar-nominated *The Royal Tenenbaums*, *Moonrise Kingdom* and *The Grand Budapest Hotel*. Graduated from ST. JOHN'S SCHOOL.

ANNEXATION
A major reason Houston grew to become the fourth-largest city in the United States. From the 1940s to the 1960s, Houston doubled its territory

twice. General-purpose annexation was limited by state law following KINGWOOD's controversial re-annexation in the 1990s. Now, limited-purpose annexations allow the City of Houston to annex a territory with commercial properties through an agreement with the utility district (the provider of water and sewer service within that territory), where a limited list of services is provided, with a split sales tax and no collected property taxes.

ANT FARM
Art collective run by UNIVERSITY OF HOUSTON architecture professors, dedicated to futuristic installations and performances. Founded in 1968.

ANTIOCH MISSIONARY BAPTIST CHURCH
Houston's oldest African American Baptist congregation, founded in 1866. Following the construction of the PIERCE ELEVATED, it was separated from FREEDMEN'S TOWN and now lives among Downtown high-rises.

ANVIL BAR & REFUGE
Artisanal cocktail bar on LOWER WESTHEIMER in CHERRYHURST, founded by Bobby Heugel, Kevin Floyd and Steve Flippo in a former Bridgestone/Firestone store. Almost single-handedly popularized elegant, complicated cocktails in Houston.

ANYTHING THAT FLOATS
Rice Design Alliance–sponsored spring event where participants are challenged to build a device on the spot with discarded items that can float a short distance on BUFFALO BAYOU.

APOLLO 11
The successful 1969 NASA mission to the moon, where Neil Armstrong spoke, "HOUSTON, TRANQUILITY BASE HERE. THE EAGLE HAS LANDED."

APOLLO 13
The failed 1970 NASA mission to the moon and a 1995 movie about the mission featuring the perpetually overused quotation, "HOUSTON, WE HAVE A PROBLEM."

ARMADILLO
A native, mostly nocturnal mammal with an armored shell. Translates from Spanish as "little armored one." It has no natural predators, unless you count automobiles, trucks, buses and so on.

ARMAND BAYOU
Pasadena waterway that runs into Clear Lake. Known for ARMAND BAYOU
NATURE CENTER, founded in 1974. Named for local environmentalist
Armand Yramatugi. Formerly Middle Bayou.

ART CAR
An existing or new car decorated with a theme, or rebuilt into something
else, but still drivable, typically allowing its creator to make a statement
or commentary and express individuality. The act of making an art car is
celebrated as subversive and belongs to the American folk art tradition. First
seen in Houston during the NOTSUOH festivals of the early twentieth century.
Popularized in the 1980s with the annual ART CAR PARADE.

ART CAR MUSEUM
Nonprofit contemporary arts museum on Heights Boulevard, featuring a
collection of ART CARS, founded by ANN O'CONNOR HARITHAS and JIM HARITHAS
in 1998. Also known as the "Garage Mahal." The chrome exterior was created
by art car artist David Best. Admission is always free to the public.

ART CAR PARADE
A springtime party and rolling exhibition of decorated and transformed vehicles
reflecting Houston's funky, subversive, do-it-yourself spirit of self-expression and
folk art. Nurtured by ANN O'CONNOR HARITHAS and LAWNDALE's *Collision* show in
1984 and featuring Larry Fuente's "Mad Cad" art car, as well as Jackie Harris's
"Fruitmobile," created for 1984's ORANGE SHOW gala. In 1986, Rachel Hecker
and Trish Herrera organized a parade for the New Music America Festival,
which featured art cars along Montrose Boulevard. On June 29, 1986, the
ORANGE SHOW hosted an art car exhibition. Following a request by the Houston
International Festival, the first official parade rolled in April 1988. Currently
sponsored by the ORANGE SHOW, it is the largest such event in the world.

ARTE PÚBLICO PRESS
The nation's largest publisher of contemporary and recovered Hispanic-
American authors, founded in 1979 by Nicolás Kanellos and based at
UNIVERSITY OF HOUSTON.

ART GUYS, THE
Offbeat, and occasionally wacky, artist collaboration of Michael
Galbreth and Jack Massing, started in 1983 as UH students with

the goal of expanding the understanding and regard of visual and performance art.

ART LEAGUE HOUSTON

Founded in 1948, this nonprofit is dedicated to the appreciation of contemporary visual art through exhibitions, outreach and, since 1983, its annual *Texas Artist of the Year* honor. The Art League School was founded in 1968 for beginner and professional artists. In 2007, it moved into a new building on Montrose Boulevard with gallery and studio space, as well as Inversion Coffee House. Not to be confused with MFAH's original name.

ARTSHOUND

Online arts and cultural events listings, including classes, performances, openings, exhibitions, auditions and employment, launched by the HOUSTON ARTS ALLIANCE in 2005.

ASHBY HIGH-RISE

Controversial, but legal, proposed high-rise on a small Bissonnet apartment complex site, adjacent to deed-restricted, residential neighborhoods SOUTHAMPTON and BOULEVARD OAKS but not beholden to their restrictions. Upset neighbors spent years protesting with political action and ubiquitous yard signs depicting a high-rise monster attacking a neighborhood.

ASIA SOCIETY TEXAS CENTER

An educational and cultural institute founded in 1979 and based on the Asia Society in New York. Opened its MUSEUM DISTRICT building in 2012, with office, gallery and theater space.

ASTRODOMAIN

The ASTRODOME campus, which once included ASTROWORLD and the AstroArena convention space and hotel.

ASTRODOME

Houston's signature landmark, opened in 1965. Built to house a Major League Baseball expansion team. Dreamed up by JUDGE ROY HOFHEINZ and publicly financed. It was the world's first indoor

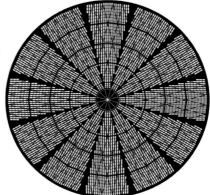

Astrodome ceiling.

baseball stadium. Former home to Houston ASTROS, Houston OILERS and the RODEO. Formally known as Harris County Domed Stadium and the NRG Astrodome. Dubbed the EIGHTH WONDER OF THE WORLD. Currently unused but not unloved. HARRIS COUNTY is working on a plan to convert it to a public park.

ASTRONAUT
A pilot, scientist, specialist or crew member who is trained to serve on a mission in space. Astronauts have also included teachers, politicians and rich tourists. NASA trains its astronauts and the JSC in CLEAR LAKE.

ASTROS, THE
Houston's Major League Baseball team since 1965. Originally named the COLT .45S. The name was derived from "astronaut." Their first home was the ASTRODOME, but they moved to Downtown's MINUTE MAID PARK in 2000. Made it all the way to the World Series in 2005 but were swept by the Chicago White Sox.

ASTROTURF
Synthetic grass used since 1966 in the ASTRODOME, where natural grass could not grow. Originally called "ChemGrass." Senator LLOYD BENTSEN is credited with coining the term when it was related to fake grass-roots political support: "A fellow from Texas can tell the difference between grassroots and Astroturf."

ASTROWORLD
Demolished theme park designed by JUDGE HOFHEINZ, adjacent to the ASTRODOME. Sold to Six Flags in 1975. Open from 1968 to 2005 and then demolished.

ATTIC FAN
Ventilation system popular in Houston prior to air conditioning. It pulls interior hot air up into a vent by pushing hot air out of an exterior vent in the attic.

AUDUBON PLACE
HISTORIC DISTRICT east of Montrose Boulevard, designated in 2009. Originally a part of the MONTROSE ADDITION and platted in 1911. North of West Alabama and east of Montrose Boulevard.

AULBACH, LOUIS
Wrote the epic and comprehensive book *Buffalo Bayou: An Echo of Houston's Wilderness Beginnings,* covering every physical aspect, all the adjacent neighborhoods and the detailed history of the signature Houston waterway.

AURORA PICTURE SHOW
Nonprofit cinema for screening and education, founded by Andrea Grover in 1998 in SUNSET HEIGHTS. Sponsors and curates short film programs throughout Houston.

AUSTIN, STEPHEN F.
(1793–1836)
Land developer, or EMPRESARIO, who was famously known as THE FATHER OF TEXAS. Led the first legal colonization of a Mexican Texas with three hundred families (THE OLD THREE HUNDRED). The town of Waterloo, Texas, was renamed for him and made the state capital.

AUTRY COURT
Five-thousand-seat basketball arena at RICE UNIVERSITY, built in 1950. Also used for large lectures and non-sports assemblies.

AUTRY HOUSE
Former RICE INSTITUTE student community house built in 1921, now part of the adjacent Palmer Memorial Episcopal Church.

AVALON DINER
River Oaks soda fountain–style restaurant and former drugstore, founded in 1938. Formerly on the corner of WESTHEIMER and KIRBY. Additional locations in Memorial and Stafford.

AVENUE CDC
Community development corporation dedicated to developing affordable housing, preserving historic structures and bringing life to the OLD SIXTH WARD, Near Northside and WASHINGTON AVENUE neighborhoods. Founded in 1991 and first known as Old Sixth Ward CDC.

AVONDALE
Residential neighborhood north of Lower Westheimer and east of Montrose Boulevard. Known for large, early twentieth-century homes. Made a HISTORIC DISTRICT in 1999 (East) and 2007 (West).

AZALEA TRAIL
Annual late-April home and garden tour hosted by the RIVER OAKS GARDEN CLUB since 1935 (known then as the Garden Pilgrimage), benefitting local public landscaping projects. Avoid driving behind anyone on the Azalea Trail, as they will be moving very slowly.

BABYGIRL
A slang term of affection for any woman or girl.

BAKER BOTTS
Prominent law firm with ties to Houston from the 1840s. Founding partner Peter Gray represented the ALLEN BROTHERS. Renamed Gray & Botts in 1865 and then became Gray, Botts & Baker with James A. Baker in 1872 and, finally, Baker & Botts in 1874.

BAKER, BURKE
(1887–1964)
Businessman, philanthropist and president of American General Life Insurance Company. Major contributor to the Burke Baker Planetarium at the Houston Museum of Natural Science.

BAKER, CAPTAIN JAMES A.
(1857–1941)
Houston lawyer who rescued WILLIAM MARSH RICE's trust for his new school, the RICE INSTITUTE. His father is the Baker of Baker Botts law firm (then Gray, Botts & Baker). Grandfather of JAMES A. BAKER III.

BAKER, JAMES, III
(1930–present)
Houston lawyer, secretary of treasury in the Reagan administration, secretary of state in the Bush administration and Republican Party problem-solver. Founded James A. Baker III Institute at RICE UNIVERSITY. Has a statue in SESQUICENTENNIAL PARK near a GEORGE H.W. BUSH statue.

BALL MOSS
An unsightly epiphyte that perches on LIVE OAK limbs and strains weaker trees; not a moss or a parasite.

BALL, TOM
(1859–1944)
Elected to the U.S. Congress in 1896. During four terms, he played a key role in funding of THE SHIP CHANNEL. Following his service in Congress, he lobbied on behalf of the Harris County Navigation District, earning

the name "the Father of the Port." TOMBALL, in north HARRIS COUNTY, was named for him.

BÁNH MÌ
Popular Vietnamese sandwich made with a French baguette, meat and peppers.

BARBECUE
Famous method for preparing food using grilling and smoke, usually outside. Also, a type of meat made by this method. Also known as BBQ, Bar-B-Q, barbacoa, 'cue and, simply, Q. Often misspelled as "barbeque."

BARKER RESERVOIR
A flood control project (along with the Barker Dam) in west Houston, north of ADDICKS RESERVOIR. Authorized in 1989 and named for Eldred Barker, the first owner of the land.

BARNSTONE, HOWARD
(1923–1987)
Houston architect and writer known for Modernist structures, including the ROTHKO CHAPEL and the RICE MEDIA CENTER. He wrote a biography of architect JOHN STAUB.

BARRIO
Spanish for "neighborhood."

BARRIO DOGS
A local nonprofit addressing animal neglect in Houston's low-income neighborhoods through outreach, education and advocacy.

BASEMENT
An extremely rare feature in Houston homes due to the clay soil and high water table.

BATTLE OF SABINE PASS
(September 8, 1963)
Civil War battle where Union troops attempted to block access by Confederates to the Sabine River as it enters the Gulf of Mexico. Confederate

DICK DOWLING led a successful defense of Sabine Pass, instantly becoming a hero to all Irish-American Texans.

BATTLE OF SAN JACINTO
(April 21, 1936)
Decisive final battle in Texas's war for independence from Mexico, on a prairie at the mouth of the SAN JACINTO RIVER. General SAM HOUSTON and the TEXIAN Army defeated President Santa Anna and the Mexican army of more than six hundred soldiers days after the Texians were murdered at the Alamo and Goliad. (Hence the phrase, "REMEMBER THE ALAMO! REMEMBER GOLIAD!")

BATTLE OF THE SEXES, THE
Epic, semi-comic 1973 tennis match between Billie Jean King and Bobby Riggs in the ASTRODOME. King easily beat the aging showboater and trash talker.

BATTLESHIP *TEXAS*
Second U.S. ship to be named *Texas*. Commissioned in 1912, it served in World War I and World War II and was decommissioned in 1948. Now a museum ship at the San Jacinto Battleground State Historic Site. Despite its current location, it is *not* the reason we won the BATTLE OF SAN JACINTO.

BAYLOR COLLEGE OF MEDICINE
Private medical school founded in 1900 as University of Dallas Medical Department and later renamed Baylor University College of Medicine. Accepted invitation from M.D. ANDERSON to move to Houston in 1943 and then relocated to the TEXAS MEDICAL CENTER in 1947.

BAYOU
A slow-moving body of water found in flat areas and near coastlines along the Gulf Coast.

BAYOU BEND
The former RIVER OAKS estate of IMA HOGG. Now the Bayou Bend Collection HOUSE MUSEUM, it is owned by MFAH and features American decorative arts and early nineteenth-century American furniture. The surrounding gardens are open to the public.

SIMS
LUCE
VINCE
HALLS
BRAYS
GREENS
GARNER
BUFFALO
ARMAND
JACKSON
HUNTING
KEEGANS
WHITE OAK
REINHARDT
CHOCOLATE
BRICKHOUSE
CARPENTERS
BAYOU

Bayous.

BAYOU CITY

A popular Houston nickname since the mid-nineteenth century, referring to the nineteen local waterways. Houston was founded on the confluence of WHITE OAK BAYOU and BUFFALO BAYOU. Other bayous within the city include Armand, BRAYS, Brickhouse, Carpenters, Cedar, Chocolate, Garner, Greens, Halls, Horsepen, Hunting, Jackson, Keegans, Luce, Reinhardt, Sims and Vince.

BAYOU CITY ART FESTIVAL

Biannual arts fair held in MEMORIAL PARK in the spring and Downtown in the fall since 1997. Formerly the Westheimer Colony Association.

BAYOU PLACE

Entertainment venue with restaurants, leasable offices, Sundance Cinemas and Bayou Music Theater (formerly Verizon Wireless Theater) since 1997. Originally constructed as the ALBERT THOMAS CONVENTION CENTER in 1967.

BAYOU PRESERVATION ASSOCIATION

A group formed in the 1960s as the Buffalo Bayou Preservation Association to protect that bayou's natural state. It was energized by the political activism of volunteer member TERRY HERSHEY. Renamed in 1969 to include all of Houston's natural waterways.

BAYTOWN

Blue-collar, oil and refinery town east of Houston. The collection of Goose Creek, Pelly and Baytown was consolidated into Baytown in 1948.

BBVA COMPASS STADIUM

Home to Houston DYNAMO soccer and TEXAS SOUTHERN UNIVERSITY football, east of Downtown; opened in 2012.

BCM

Short for BAYLOR COLLEGE OF MEDICINE.

B-CYCLE
The City of Houston's loaner bicycle program, initiated in 2012.

BEARD, THE
Nickname for bearded HOUSTON ROCKETS shooting guard James Harden. Rockets' fans wear fake beards to games as a way to root for him.

BEAUMONT CLAY
Houston's layer of packed dirt with no bedrock underneath. Instead of anchoring piers to solid rock, Houston skyscrapers rely on heavy foundations that float on geological sub-layers.

BEER BIKE
A RICE UNIVERSITY bike race and drinking competition among residential colleges since 1957.

BEER CAN HOUSE, THE
Former residence of John Milkovich at 222 Malone, clad in nearly fifty thousand flattened aluminum beer cans; now a folk art landmark owned by THE ORANGE SHOW.

BELDEN'S
Supermarket in MEYERLAND with extensive selection of kosher products.

BELLAIRE, CITY OF
Small, self-governing city on the West Loop, surrounded by Houston, platted in 1908 and incorporated in 1918. Identified by its red street signs.

BELLAIRE TRIANGLE
Retail area where Bellaire Boulevard crosses Bissonnet, before Chimney Rock. Opened in 1959.

BELL, ARCHIE
(1944–present)
Houston-based soul singer, leader of Archie Bell & the Drells. Had the number one song "TIGHTEN UP" in 1968, recorded in Houston in 1967.

BELTWAY 8
Houston's eighty-eight-mile outer loop, started in 1983 and completed in 2011. It is a toll way in some locations. Also known SAM HOUSTON PARKWAY.

BEN TAUB
Harris County's Public Health hospital in the MEDICAL CENTER, opened in 1989 and named for real estate developer and philanthropist BEN TAUB.

BENTSEN, LLOYD
(1921–2006)
Houston businessman, U.S. senator and secretary of the treasury. Defeated GEORGE H.W. BUSH in the 1970 U.S. Senate race, but Bush got even in 1988 when Bensten was on the ticket with Michael Dukakis. Awarded the Presidential Medal of Freedom in 1999.

BERGER, SIDNEY
(1936–2013)
Professor at UNIVERSITY OF HOUSTON's School of Theatre and Dance and founder of the HOUSTON SHAKESPEARE FESTIVAL at MILLER OUTDOOR THEATRE in 1975.

BERRYHILL
Mexican restaurant chain founded in 1993 based on Walter Berryhill's homemade tamales, which he sold from a cart from 1928 until the 1960s. Now Berryhill Baja Grill.

BEST LITTLE WHOREHOUSE IN TEXAS, THE
The 1978 Broadway play by Larry L. King, Peter Masterson and Carol Hall about the famed Chicken Ranch in La Grange, Texas, and the efforts to close it down by reporter MARVIN ZINDLER.

BEY
Nickname for BEYONCÉ.

BEYONCÉ
(1981–present)
Formally known as Beyoncé Knowles. Native Houstonian, singer, dancer and actor who attended HSPVA. She hit the big time with R&B group DESTINY'S CHILD. She sang the national anthem at President Obama's Second Inauguration in 2013. Also known as BEY, QUEEN B and MISS 3RD WARD.

BEZOS, JEFF
(1964–present)
Founder and CEO of Amazon. Attended River Oaks Elementary School.

"B-G-O"
Popular cheer for ASTROS legend CRAIG BIGGIO.

BIDGE
Popular nickname for ASTROS legend CRAIG BIGGIO.

BGO.

BIG AIRPORT, THE
Nickname for BUSH INTERCONTINENTAL AIRPORT.

BIG ALEX
Rooftop concrete sculpture in MONTROSE by DAVID ADICKES depicting a French-style telephone with Alexander Graham Bell's face, created in 1984.

BIG BUBBLE
A semi-secret art installation where an unmarked button releases compressed air below the surface of BUFFALO BAYOU at the Preston Street Bridge. Designed by Dean Ruck and built in 1998 as part of SESQUICENTENNIAL PARK. Nicknamed the BUBBLE BUTTON.

BIG DRUNK
Nickname the CHEROKEES gave to SAM HOUSTON that was used by his political foes and followed him the rest of his life.

BIG E, THE
Nickname for UNIVERSITY OF HOUSTON and HOUSTON ROCKETS' center Elvin Hayes. Played in the "GAME OF THE CENTURY."

BIGGERS, JOHN
(1924–2001)
African American muralist who founded the TSU Art Department in 1949.

BIGGIO, CRAIG
(1965–present)
Arguably the best player for the Houston ASTROS. Played his entire twenty-year career here and has 3,060 career hits. The ASTROS retired

his number, 7. National spokesman for the SUNSHINE KIDS FOUNDATION. The first Astro to be inducted into the Baseball Hall of Fame as an Astro.

BIG OIL
Nickname for the oil industry and all the multinational corporations searching for, extracting, refining and selling crude oil and its byproducts.

BIG SAM
Nickname for *Tribute to Courage*, the sixty-seven-foot tall statue of SAM HOUSTON near HUNTSVILLE by DAVID ADICKES, built in 1994.

BIG SHOW, THE
The annual summer open-call juried exhibition at LAWNDALE ART CENTER, featuring new and emerging artists.

"BIO"
Early twentieth-century local pronunciation of *bayou*—less common lately.

BLACK ANGUS, THE
Former forty-year RIVER OAKS area restaurant. Perpetually missing a stolen letter *G*. Old school–style eatery known for steaks and chops. Reopened briefly as the relocated Confederate House and then the State Grille. Now demolished.

BLACK, CLINT
(1962–present)
Genial country singer and songwriter raised in Houston. Married to actor Lisa Hartman Black.

BLACK GOLD
Nickname for CRUDE OIL.

BLAFFER GALLERY
Art museum of the UNIVERSITY OF HOUSTON, founded in 1973 and named for Sarah Campbell Blaffer. Known for showcasing contemporary art through programs, exhibitions and publications. Reopened in 2012 after remodeling with a dramatic new outward-facing entrance. Always free to the public.

"BLEEDING ORANGE"
A phrase describing any person loyal to the University of Texas LONGHORNS. Their team color is BURNT ORANGE.

BLOOD AND MONEY
Thomas Thompson's true crime novel published in 1976, depicting the murder of RIVER OAKS socialite Joan Robinson Hill in 1969 and, later, murder of her husband, Dr. John Hill, in 1972.

BLUE AND WHITE TILES
A civic improvement detail in which street names were depicted with three-fourth-inch square tiles embedded into concrete curbs from the 1920s to the 1960s. Now they are mostly ignored when curbs are replaced. Lately, MIDTOWN has experimented with tiles on the sidewalks.

BLUEBONNET
The state flower of Texas since 1901.

BLUE DOOR, THE
Nickname for MARFRELESS, a speakeasy-style unmarked bar (and former landmark), an infamous make-out spot from 1972 to 2013.

BLUE HERON FARM
A local goat dairy farm owned by Lisa and Christian Seger, opened in 2006, specializing in high-quality goat cheeses.

BLUE LAWS, THE
Leftover religious laws preventing/limiting sale of booze on Sundays. Once included retail stores and gas stations.

BLUE ROOF
Nickname for any home that sustained damage from HURRICANE IKE and received a temporary roof tarp from FEMA before repairs could be made.

BLUE TREES, THE
An outdoor art installation at the Waugh/Memorial interchange, where Konstantin Dimopoulos and volunteers covered the trunks of existing crepe myrtles with nontoxic blue paint. Sponsored by Houston Arts Alliance in 2013.

B19
Nickname for RIVER OAKS' swanky restaurant/bar Brasserie 19.

BOBBINDOCTRIN PUPPET THEATRE
Experimental, adult puppet performances employing a variety of puppetry techniques including hands, masks, rods, shadows, strings and tabletops in original works since 1995.

BOOKED UP
Author LARRY MCMURTRY's bookshop in Houston, now located in Archer City, Texas.

BOOKSTOP
Chain bookstore that restored the ailing Art Deco ALABAMA THEATRE in 1984. Later, WEINGARTEN Realty removed the interior architectural distinctiveness. Now a Trader Joe's.

BOOM
Short for OIL BOOM.

BOOTOWN
Artsy, nonprofit theatrical group dedicated to producing nontraditional shows, including plays, the monthly series *Grown-Up Storytime* and hilarious Neo Benshi shows. Founded in 2007.

BORDEN, GAIL
(1881–1874)
Surveyor who plotted Houston and GALVESTON. Co-publisher of the *TELEGRAPH AND TEXAS REGISTER* newspaper. Inventor of non-spoiling beef biscuit, he also patented and got rich with a new process for condensing milk.

BOTTOMS, THE
Economically distressed northern area of the THIRD WARD.

BOULEVARD OAKS
Residential neighborhood north of Bissonnet and east of South Shepherd Drive. Known for its large, early twentieth-century homes and mature live oaks along NORTH and SOUTH BOULEVARDS. Listed on the National Register of Historic Places. HISTORIC DISTRICT since 2009.

"Bow Down/I Been Down"
A controversial song by Beyoncé with aggressive and empowering lyrics; she name-drops H-Town, Frenchy's, Willie D, Pimp C and UGK.

Bowlegged H
The orange, H-shaped, cowboy-hat-and-boots-wearing mascot and logo of the Houston Livestock Show and Rodeo.

Boyhood
Award-winning movie by Richard Linklater shot over twelve years in Houston, Austin and throughout Texas and released in 2014.

Braeswood Place
Subdivision in southwest Houston along Braes/Brays Bayou, developed in the 1950s and known for ranch-style, single-family homes.

Brays Bayou
Thirty-one-mile waterway that begins in southwest Harris County, flowing eastward to the Ship Channel. Channelized with concrete in 1968, it collects stormwater from Fondren Southwest, Braeswood, Bellaire, West University, the Medical Center, Riverside Terrace, Idylwood and the East End. Includes a paved twelve-mile trail rail from Gessner to MacGregor Park.

Brazos Bookstore
Independent bookstore opened in 1974 by Karl Kilian, specializing in personalized service and community engagement. Upon Kilian's retirement in 2006, a group of twenty-seven concerned neighbors and customers purchased the store.

Brennan's
Founded in 1967 as a sibling to the Commander's Palace in New Orleans and specializing in Texas Creole. The John Staub–designed building in Midtown was home to the Junior League of Houston and suffered a catastrophic fire the night Hurricane Ike made landfall in 2008, but it was rebuilt and now surpasses its former glory.

Brewster McCloud
The 1970 Robert Altman film about a man-boy who lives in the Astrodome and dreams of flying.

BRINKLEY, DOUGLAS
(1960–present)
Historian, professor at RICE UNIVERSITY and author of books on HURRICANE KATRINA and Houston-raised WALTER CRONKITE.

BRISCOE, BIRDSALL
(1876–1971)
Twentieth-century architect known for upscale homes in BROADACRES, COURTLAND PLACE, RIVER OAKS and SHADYSIDE.

BROADACRES
Residential neighborhood north of Bissonnet and west of Montrose Boulevard. Established in 1923 by the Baker family and designed by WILLIAM WARD WATKIN. Known for its early twentieth-century mansions and mature LIVE OAKS along NORTH and SOUTH BOULEVARDS. Listed on the National Register of Historic Places. It has been a HISTORIC DISTRICT since 2007.

BRO BAR
From the white guy term of affection "brother," pronounced "braw." A typically faux-exclusive bar that caters to young, noisy, flashy men and women, but less so to African Americans. It typically has a velvet rope and doorman, many televisions and bottle service. Lately found along WASHINGTON AVENUE, although these bars have flourished on the RICHMOND STRIP and in the GALLERIA area, MIDTOWN and UPPER KIRBY.

BROKEN OBELISK
The 1963 Barnett Newman Cor-Ten steel sculpture installed in front of the ROTHKO CHAPEL in 1971, from efforts by JOHN DE MENIL, and dedicated to Martin Luther King Jr. after it was rejected as a gift to the City of Houston in 1969.

BROWN & ROOT
Road building company founded in 1919 by bothers George and Herman Brown and Daniel Root. With government contracts during and after the Great Depression, it grew into a large, international construction company. Acquired by HALLIBURTON in 1962 as a subsidiary, it merged with M.W. Kellogg in 1998 (becoming KBR) and then broke off in 2007.

BROWN BOOK SHOP
Downtown technical bookstore founded in 1946 by Sylvia and Ted Brown.
Multiple generations of engineers and architects have shopped here.

BROWN, GEORGE R.
(1898–1983)
Houston entrepreneur and philanthropist who founded Brown & Root. Also
founded the Brown Foundation in 1951. GEORGE R. BROWN CONVENTION
CENTER is named for him. DISCOVERY GREEN has a statue of him.

BUBBA
Nickname and a term of endearment for "brother." Can also be used outside
of family among friends. Can be used to describe a "good ol' boy" or an
unpretentious, blue-collar man. Sometimes pejorative.

BUBBLE BUTTON, THE
Nickname for BIG BUBBLE, a semi-secret art installation where an unmarked
button releases compressed air below the surface of BUFFALO BAYOU at the
Preston Street Bridge. Designed by Dean Ruck and built in 1998 as part of
SESQUICENTENNIAL PARK.

BUCKYBALLS
Nickname of Buckminsterfullerene, a molecule made of twenty hexagons
and twelve pentagons bonded by carbon, resembling a geodesic design, and
first made at RICE UNIVERSITY.

BUDDY
Childhood nickname of PATRICK SWAYZE.

BUFFALO BAYOU
Signature waterway of Houston, originating on the Katy Plain to the
west and traveling east through the ADDICKS RESERVOIR, Memorial,
Tanglewood, MEMORIAL PARK, RIVER OAKS, ALLEN PARKWAY, Downtown
and EAST END, where it becomes THE SHIP CHANNEL and empties into
Galveston Bay. At the confluence with White Oak, it marks the place
where the ALLEN BROTHERS founded Houston. Prior to Houston, other
Anglo communities were established along Buffalo Bayou, including
HARRISBURG and FROST TOWN. Until the early twentieth century, it acted
as a sewer for Houstonians. First major commercial travel and activity

was started in Houston on Buffalo Bayou, considered to be the highest point a ship could travel. Continuous dredging allowed for increasingly larger ships and the formation of THE SHIP CHANNEL. Named for the freshwater buffalo fish.

BUFFALO BAYOU PARK
A 124-acre park along BUFFALO BAYOU, ALLEN PARKWAY and Memorial Drive from Shepherd Drive to Downtown, with many great views of the Downtown skyline. Noteworthy for its hills in an otherwise flat city. Includes ELEANOR TINSLEY PARK, Lee & Joe Jamail Skatepark, Sandy Reed Trail, Gus Wortham Memorial Fountain, the Police Officer Memorial, Rosemont Bridge, the Johnny Steele Dog Park and the WAUGH BRIDGE BAT COLONY.

Houston Buffs.

BUFFALOES, THE
(1928–1961)
St. Louis Cardinals' Triple A, minor-league baseball team named for BUFFALO BAYOU. Moved away when the major-league COLT .45S came to town. Their home was BUFF STADIUM, at the corner of Cullen Boulevard and the GULF FREEWAY; it was renamed Busch Stadium in 1955 and then demolished in the early 1960s.

BUFF STADIUM
Nickname of the minor-league baseball Buffalo Stadium, home of the BUFFALOES, the St. Louis Cardinals' Triple A team, from 1928 to 1961. The site of a Fingers furniture store, with a Houston sports museum in the basement, from 1965 to 2013.

BUFFS, THE
Nickname for minor-league baseball team the BUFFALOES.

BULLS ON PARADE
Nickname for Houston TEXANS' defense, coined by linebacker Connor Barwin in 2011 from the Rage Against the Machine song of the same name.

BUN B
(1973–present)
Beloved, socially active, local hip-hop artist and guest lecturer at RICE UNIVERSITY. Formerly part of the duo UGK. Popularized the term TRILL.

BUNNIES ON THE BAYOU
Annual outdoor cocktail party/fundraiser on Easter Sunday at WORTHAM THEATER/SESQUICENTENNIAL PARK supporting local LGBT charities since the 1990s.

BURNT ORANGE
The team color for the University of Texas Longhorns.

BUSH
Nickname for Houston's main municipal airport, formerly Houston Intercontinental Airport, opened in 1969. Named for President GEORGE H.W. BUSH. Also known as INTERCONTINENTAL, IAH and THE BIG AIRPORT.

BUSH, GEORGE H.W.
(1924–present)
World War II veteran, local OILMAN and co-founder of ZAPATA PETROLEUM COMPANY. Served Houston in U.S. Congress, where he helped protect BUFFALO BAYOU from channeling. Served as vice president and as forty-first president of the United States. Also known as "Bush Sr.," "Bush 41" and "Poppy." Has statues in SESQUICENTENNIAL PARK and BUSH INTERCONTINENTAL AIRPORT. Married to Barbara Bush and father to the forty-third president of the United States, George W. Bush; Florida governor Jeb Bush; Neil Bush; Marvin Bush; and Dorothy Bush Koch.

BUSH, JOHNNY
(1935–present)
County singer/songwriter from Kashmere Gardens. Wrote the song "WHISKEY RIVER" and had a hit with it before his friend WILLIE NELSON made it his signature song.

BUSHWICK BILL
(1966–present)
Member of Houston's GETO BOYS with SCARFACE and WILLIE D. Rapped about the FIFTH WARD on hip-hop masterpiece "MIND PLAYING TRICKS ON ME."

BUST
Short for OIL BUST.

BYRD, SIGMAN
Reporter for the *HOUSTON PRESS*. Wrote book about the seedy, alcoholic underside of Downtown in *Sig Byrd's Houston* in 1955.

CABEZA DE VACA, ÁLVAR NÚÑEZ
(1488–1558)
Spanish explorer who was shipwrecked at GALVESTON ISLAND in 1528. The first European to explore present-day Houston and BUFFALO BAYOU. Enslaved by local American Indians before escaping.

CACTUS MUSIC
Legendary, MONTROSE-area music store known for in-store performances. Closed its thirty-year location next to the ALABAMA THEATRE in 2006 and then reopened with new owners in 2007 down the street. Also known as CACTUS.

CAFÉ BRASIL
Among the first to bring café culture to MONTROSE in the early 1990s. Owner Dan Fergus renovated a former bicycle shop into a neighborhood focal point for a variety of coffee, desserts, live music and art installations. Prior to Brasil, and Empire Café down the road, Houston had virtually no café-style coffee shops.

CAME IN
Term for striking OIL, as in "my oil well came in."

CAMELBACK
A style of home addition popular in the historic OLD SIXTH WARD, where building codes prohibit the alteration to the front elevation of the property or an increase in the building's footprint. The result is a small one-story home with a large, two- or three-story backside. Also known as a "humper house" or "humping bungalow."

CAMH
The Contemporary Arts Museum Houston. Also known as "the Cam." Founded in 1948, it built a permanent home on the corner of Montrose Boulevard and Bissonnet, designed by Gunnar Birkerts, in 1972. Always free to the public.

CAMP LOGAN
World War I army training camp in what is now MEMORIAL PARK. Known for 1917's Camp Logan Race Riot and 1918's SPANISH INFLUENZA outbreak.

CAMPOS
Nickname for the RICE UNIVERSITY campus police.

CAN-DO CATHEDRAL
Nickname for the ASTRODOME.

CAPITAL
The REPUBLIC OF TEXAS House and Senate chose Houston as the temporary capital in 1836. The capital moved to Waterloo (now Austin) in October 1839.

CAPITOL HOTEL
Former Downtown location of the capitol of the REPUBLIC OF TEXAS until 1839, prior to relocation to Austin. The former capitol building was converted into a hotel. Location of former president ANSON JONES'S suicide in 1858. The two-story hotel was rebuilt in 1883. It was demolished and rebuilt by JESSE JONES in 1913 as the RICE HOTEL. In 1998, developer Randall Davis converted it to the Rice Lofts, with units for rent, the Crystal Ballroom and street-level restaurants.

CARAFE, LA
Beer and wine bar open since 1962 in the KENNEDY BAKERY BUILDING, built in 1861. Widely considered to be Houston's oldest commercial building. Incorrectly identified as Houston's oldest bar (see LEON'S LOUNGE).

CARRABBA'S
Johnny Carrabba joined Damian MANDOLA to found the popular Carraba's Italian Grill restaurant chain.

CARTER, GOREE
(1930–1990)
Native Houstonian, R&B singer and guitarist. His 1949 song "Rock Awhile" is considered by journalist Robert Palmer to be the first true rock-and-roll recording.

CASA DE ESPERANZA
A shelter for children who need residential, medical or psychological care, founded in 1982. Since 1986, it has also specialized on HIV-positive children.

CATASTROPHIC THEATER
Alternative ensemble theater company founded in 2007 by Tamarie Cooper and Jason Nodler out of the ashes of Infernal Bridegroom Productions.

CERTIFICATE OF APPROPRIATENESS
A City of Houston document required in exterior appearance changes to a historic structure prior to obtaining a building permit. It can help to ensure and/or return the lost and/or diminished architectural significance of a historic structure.

CHAMILLIONAIRE
(1979–present)
Native Houstonian, hip-hop artist and entrepreneur. Convinced MICHAEL "5000" WATTS to allow him and friend PAUL WALL to freestyle on Watts's radio show and became a fixture in the mixtape scene. Signed by Swishahouse. Won a Grammy for Best Rap Performance by a Duo or Group for "Ridin'."

CHAPMAN, BETTY TRAPP
A Houston historian and author of several books, including *Historic Photos of Houston, Remembering Houston* and *Houston Women: Invisible Threads in the Tapestry.*

CHAPTER 42
A 1999 City of Houston development ordinance that defines "urban" as inside THE LOOP and "suburban" as outside. In areas without DEED RESTRICTIONS, it allows developers in urban settings more leeway in subdividing lots. A small step toward ZONING. Inside THE LOOP, townhouses can be built at twenty-seven units per acre. Amended in 2013 to allow an increased limit on townhome density for the land bounded by LOOP 610 and Beltway 8.

CHASE TOWER
JPMorgan Chase Building, a seventy-five-story Downtown office building designed by I.M. Pei and built by GERALD HINES, opened in 1981. Houston's tallest building since its completion. Originally named Texas Commerce Tower. The sky lobby on the sixtieth floor is open to the public. Joan Miró's fifty-five-foot steel and cast bronze sculpture *Personage and Birds* stands at the entrance plaza.

CHELSEA MARKET
Retail and restaurant development on Montrose Boulevard in the MUSEUM DISTRICT since 1985.

CHEROKEES
Native American group that populated the mid-southern region of the United States. By the nineteenth century, the Cherokees had assimilated European American conventions. SAM HOUSTON lived with the Cherokees as a young man, as well as following his resignation as governor of Tennessee. They gave him the name COLONNEH, or THE RAVEN.

CHERRYHURST
Deed-restricted Montrose-area residential neighborhood, north of Westheimer and west of Waugh, known mostly for one-story brick bungalows and middle-aged hipsters.

CHERRYHURST HOUSE
Visual arts gallery and private residence in CHERRYHURST. Collector Dallas McNamara converted the two bungalows, connected them and opened in 2014.

CHICKEN-FRIED STEAK
A near-ubiquitous and intentionally un-fancy Texan dish served anywhere where red meat rules the menu. Typically a cheap steak, breaded and then deep fried and served covered in cream gravy. Best local versions can be found at Hickory Hollow, Jax and 59 Diner, with Luby's and Cleburne fighting it out for the best cafeteria version.

CHI-FRI
Nickname for CHICKEN-FRIED STEAK.

CHIN, MEL
(1951–present)
Native Houstonian and visual artist known for public installations and sculptures, as well as *The Manila Palm* outside the CAM.

"CHOKE CITY"
A mocking *HOUSTON CHRONICLE* headline after the HOUSTON ROCKETS blew leads in their first two championship games in 1994.

CHOPPED AND SCREWED
A local hip-hop remix technique of slowing down the tempo and adding scratching and beat skipping, popularized by DJ SCREW in the early 1990s.

CINCO RANCH
A five-thousand-acre master-planned development in KATY, founded in 1984.

CISTERN, THE
A long-forgotten, recently discovered drinking water reservoir, built in 1927 near the Sabine Street Bridge and built into the landscape, with 25-foot-tall concrete columns and 87,500 square feet.

CITE
A quarterly magazine of RICE DESIGN ALLIANCE, published first in 1982. *Cite: The Architecture & Design Review of Houston* covers all types of local architectural projects and encourages deeper public conversation on private and public design, including preservation, history, civic engagement and opinion.

CITIBILLY
Term for a country hick who moves to the big city but fails to adapt to the city ways. Coined by LARRY MCMURTRY in his 1968 essay "A Handful of Roses."

"CITIZEN KANE OF CHAPELS"
Compliment paid by filmmaker WES ANDERSON to the landmark ROTHKO CHAPEL in 2014.

CLAYTON, WILL
(1880–1966)
A co-founder with M.D. ANDERSON of Anderson, Clayton and Company, the world's largest COTTON trading company, which he relocated to Houston in 1916. His summer house was the first home in RIVER OAKS. Active in the creation of the Marshall Plan following World War II.

CLEAR LAKE
Community in southeast Houston, named for the adjacent lake that connects to GALVESTON BAY. Grew quickly following the establishment of NASA/JOHNSON SPACE CENTER in 1963 and the nearby supporting aerospace engineering firms. Includes communities Webster, League City, Nassau Bay, Seabrook, Kemah and Bacliff, as well as the ARMAND BAYOU NATURE CENTER. Annexed by Houston in 1977.

CLEMENS, ROGER
(1962–present)
Major-league baseball pitcher. Went to Spring Woods High School. Played for the Houston ASTROS from 2004 to 2006, including their only appearance in the World Series. He was found not guilty of perjury after his Congressional testimony denying steroid use. Nicknamed THE ROCKET. He unapologetically gave all of his sons names starting with *K* (shorthand for a strikeout).

"CLUB NO MINOR"
Makeshift sign at El Patio's Westheimer/Briargrove location indicating TABC rules since the 1950s. Nickname for same restaurant where countless Memorial and Lee High School students drank for the first time.

CLUTCH
The bear mascot for the HOUSTON ROCKETS. Derived from the CLUTCH CITY nickname.

CLUTCH CITY
Celebratory nickname for HOUSTON ROCKETS after winning NBA championship, responding to a poor start and a taunting "CHOKE CITY" newspaper headline in 1994.

COASTAL PRAIRIE
Geographical region where Houston is sited.

CO-CATHEDRAL
Nickname for the Galveston-Houston Catholic Diocese Co-Cathedral of the Sacred Heart built in 2008 in Downtown, replacing nearby Sacred Heart Catholic Church from 1912. The Catholic Diocese of GALVESTON was renamed the Galveston-Houston Catholic Diocese in 1959, reflecting Houston's local dominance.

COH
Abbreviation for City of Houston (the city government).

COKE
Slang for any type or brand of sweetened carbonated beverage.

COLLEGE PARK CEMETERY
African American cemetery on West Dallas, opened in 1896 (then San Felipe de Austin Road). Final resting place of JACK YATES and more than four thousand others, including many freed slaves. A nonprofit was formed in 2010 to address restoration, preservation and maintenance. Formally known as College Memorial Park Cemetery.

COLLEGE STATION
Small town northeast of Houston and home to TEXAS A&M UNIVERSITY.

COLLEGIATE CLEANERS
Family-owned dry cleaners since 1947. The oldest business in RICE VILLAGE.

COLONNEH
Cherokee for THE RAVEN, SAM HOUSTON's name when he lived among them.

COLT .45S, THE
The original name for the Major League Baseball team the Houston ASTROS, established in 1962. They played in Colt Stadium adjacent to what would become the ASTRODOME. Colt's Manufacturing Company objected to the use of its brand name, and the team was renamed upon moving into the new Astrodome in 1965.

COLUMBIA BLUE
The light-blue Houston OILERS' uniform color.

COLUMBIA TAP TRAIL
The four-mile-long, ten-foot-wide paved bike trail in the THIRD WARD, on the former Columbia Tap rail line. Completed in 2009, it runs from St. Charles Street in EADO through the TSU campus to Dixie Street, connecting to BRAYS BAYOU.

COMBAT KROGER
Chain grocery store on Cullen and Polk, so-called by UH students less accustomed to the blue-collar customers.

COMEDY WORKSHOP
Former comedy club on Shepherd at San Felipe where comedians BILL HICKS and Sam Kinison got their start.

COMETS, THE
Women's National Basketball Association team in Houston, founded in 1997. One of the first teams in the newly formed WNBA. They won four championships. The team was disbanded in 2008.

COMPAQ
Computer manufacturing company founded by managers from Texas Instruments in 1982, with headquarters north of Houston. Originally named Gateway Technology. Known for its "portable" IBM PC compatible computers, or clones. After years of struggles in the 1990s, it was bought out by Hewlett-Packard in 2002. The SUMMIT was named the Compaq Center in 1998 and until the ROCKETS moved out and LAKEWOOD CHURCH moved in.

CONDENSED MILK
GAIL BORDEN, Houston's first surveyor, newspaper publisher and inventor, patented an innovative way for condensing milk in 1853.

CONFEDERACY, THE
The Confederate States of America was the government formed by U.S. states that seceded illegally from the Union, prompting the Civil War. Texas was a Confederate state.

CONGREGATION BETH ISRAEL
The oldest Jewish congregation in Texas, tracing its origins to the Hebrew Congregation Beth Israel in 1854. Founded as an Orthodox congregation, the group began to move toward Reform Judaism in the 1860s. Beth Israel moved to its current campus on North Braeswood in 1967 and now has more than 1,700 families.

CONJUNTO
A genre of Mexican/Tejano music born in South Texas when German immigrants introduced the accordion to existing styles in the late nineteenth century.

CONTAINER SHIP
A type of cargo ship that uses containers that can fit on a typical large, semi-trailer truck or eighteen-wheeler. The first, *IDEAL X*, arrived on its maiden voyage at the PORT OF HOUSTON in May 1956.

CONTEMPORARY ARTS MUSEUM HOUSTON
Also known as "the Cam." Founded in 1948 and built a permanent home on the corner of Montrose Boulevard and Bissonnet, designed by Gunnar Birkerts, in 1972. Always free to the public.

CONTRIBUTING STRUCTURE
A building or structure that has characteristics that reinforce, or could reinforce, the historical significance of a HISTORIC DISTRICT.

COOGS
Nickname for the COUGARS, the UNIVERSITY OF HOUSTON athletic teams.

COOKOFF, THE
Nickname for the World's Championship Bar-B-Que Contest. Since 1974, it has been a massive BARBECUE contest at the beginning of the annual HOUSTON LIVESTOCK SHOW AND RODEO, typically with more than 350 professional and amateur teams. Private and public tents are filled with food, drink and music. Always a hot ticket item.

COOLEY, DENTON
(1920–present)
Pioneering heart surgeon who replaced a human heart with a temporary mechanical heart in 1969. Had a famous decades-long feud with fellow surgeon MICHAEL DEBAKEY but reconciled before DeBakey's death. Founded the TEXAS HEART INSTITUTE.

COOLIDGE
Houston street artist who creates small, stenciled spray-painted images.

CORE PROGRAM
Visual art fellowship program at MUSEUM OF FINE ARTS, HOUSTON's GLASSELL SCHOOL, providing studio space, stipend, support and an annual exhibition, established in 1982.

CORINTHIAN, THE
Since 2002, a posh Downtown party venue served exclusively by caterer JACKSON HICKS. Named for the thirty-five-foot-high Corinthian columns in its Great Hall. The Neoclassical building was first home to the First National Bank in 1905, it was the first steel-framed structure in Houston

and it was among its first skyscrapers. Above the Great Hall are the Franklin Lofts.

COTTON
The major commodity of Houston traders from the 1860s onward. It became a major export through Houston following the introduction of railroads. M.D. ANDERSON and WILL CLAYTON built the largest cotton company in the world and headquartered it in Houston.

COTTON EXCHANGE, THE
The Houston Cotton Exchange and Board of Trade Building opened in 1884 as the epicenter of Houston's COTTON business, adjacent to rails and Produce Row in MARKET SQUARE. Took the lead in promoting Houston's development, including lobbying the U.S. Congress to improve THE SHIP CHANNEL.

COUGAR HIGH
Derogatory name for UNIVERSITY OF HOUSTON—less common lately.

COUNTERCURRENT
A visual and performing arts festival presented by the MITCHELL CENTER FOR THE ARTS at UNIVERSITY OF HOUSTON, founded in 2014.

COUNTY JUDGE
The leader of the four-person county Commissioners' Court in the State of Texas, the administrative head of county government. Not actually a judge and has no veto power but votes as a member of the Commissioners' Court.

COURTLAND PLACE
Established in 1907. Upscale, gated and residential neighborhood. One block long, with eighteen homes, south of LOWER WESTHEIMER and east of Montrose Boulevard. Known for its early twentieth-century mansions. Listed on the National Register of Historic Places. HISTORIC DISTRICT since 1996.

COWBOY
Texas stereotype that never really took hold in Houston, despite the efforts of the national media and the presence of the annual RODEO. Houston was never a cowtown like Fort Worth.

CRANES

Heavy-duty lifting equipment used in the construction of high-rises. Houstonians love seeing these throughout the city because they indicate a boom is on.

CRAWFISH

Edible freshwater crustaceans raised and harvested mostly in Louisiana. Also known as crayfish, crawdads and MUDBUGS. CRAWFISH BOILS are popular throughout the GULF COAST in the spring.

CRAWFISH BOIL

A public event where a group or place will serve boiled red crawfish in the Gulf Coast Cajun style with cayenne pepper, hot sauce and garlic, with sides of corn and potatoes and plenty of beer to wash it down.

CREOLE

Locally, it refers to Louisiana or East Texas culture, especially food and language, where old-world European conventions meet African and Caribbean influences.

CRONKITE, WALTER
(1916–2009)
Broadcast journalist and network news anchor. Attended Lanier Junior High and San Jacinto High School. Once considered to be "the most trusted man in America."

CROOKED E
Nickname for the ENRON logo.

CROWELL, RODNEY
(1950–present)
Singer/songwriter and author who grew up in Houston. He released the 2001 album *THE HOUSTON KID* and wrote about Houston's south side in his 2011 memoir *Chinaberry Sidewalks*.

CRUDE OIL

Formally known as PETROLEUM and informally know as OIL. Removed from geological deposits and refined into gasoline, kerosene, asphalt and the chemicals in plastics. A major supply of crude oil was discovered at SPINDLETOP in 1901 and heralded the oil boom in Texas. Houstonians nervously watch its market price to gauge the health of the economy.

CSAW
Commerce Street Artists' Warehouse. Founded in 1985, east of Downtown, with cheap rented studio spaces and a performance space.

CULLINAN, JOSEPH S.
(1860–1937)
Oil industrialist who moved his business to SPINDLETOP and co-founded the Texas Company, later renamed TEXACO. Moved company from Beaumont to Houston in 1908, making Houston the oil capital of the region. He was a major patron of the arts and developed SHADYSIDE subdivision for his friends.

CULTUREMAP
Online arts, fashion, entertainment and society news source, founded in 2009.

CURVE, THE
Three narrow portions of LOWER WESTHEIMER Street where it stops going straight (the first at Stanford Street, the second at Waugh and the third at Windsor). Known for vintage clothing stores, bars, tattoo parlors and gay culture. Lately, upscale restaurants like Dolce Vita, Uchi, El Real, Underbelly, ANVIL, DA MARCO and Hugo's have found homes here.

CY-FAIR
Nickname for the Cypress-Fairbanks community northwest of Houston.

CYNTHIA WOODS MITCHELL PAVILION
Outdoor performing arts amphitheater in the WOODLANDS since 1990, named for the wife of Woodlands founder GEORGE MITCHELL.

CY TWOMBLY GALLERY
Opened in 1996, commissioned by DOMINIQUE DE MENIL and designed by RENZO PIANO to house a retrospective of works by visual artist Cy Twombly, directly across the street from the MENIL COLLECTION.

DA CAMERA
Performing arts organization dedicated to presenting and producing ensemble music, including chamber music and jazz, founded in 1987. Partners with the MENIL COLLECTION. Member of the Houston Theater District.

DA MARCO
Italian restaurant in MONTROSE on THE CURVE, widely considered the best in town. Founded by Houston chef Marco Wiles in 2000.

DANDELION FOUNTAIN, THE
Gus Wortham Memorial Fountain on ALLEN PARKWAY near Waugh, designed by architect William Cannady and installed in 1978. The bronze fountain was a gift to the city from the Wortham Foundation and American General Insurance. Rest stop for countless dogs and dog walkers.

Dandelion Fountain.

DASH, THE
Houston's National Women's Soccer League team, founded in 2013.

DEBAKEY, MICHAEL (1908–2008)
Pioneering heart surgeon and medical innovator. Served in World War II and helped develop Mobile Army Surgical Hospital (MASH) units. Helped develop the Veterans Administration Medical Center Research System. Joined BAYLOR COLLEGE OF MEDICINE in 1948 and later served as chairman of the Department of Surgery, as college president and as chancellor. Had a famous decades-long feud with fellow surgeon DENTON COOLEY but reconciled before his death. Awarded the Presidential Medal of Freedom in 1969, the National Medal of Science and the Congressional Gold Medal in 2008. The first Houstonian to lie in repose in city hall.

DECK, DANNY
Fictional Houston writer from LARRY MCMURTRY's *Moving On, All My Friends Are Going to Be Strangers* and *Some Can Whistle*.

DEED RESTRICTIONS
Neighborhood design rules and limitations to the use of the property intended to preserve that neighborhood's character. In a city without ZONING, deed restrictions allow a community to prevent the invasion of incompatible buildings. Also known as restrictive covenants.

DELL, MICHAEL
(1965–present)
Houston native and nerd/billionaire/philanthropist. Founder & CEO of Dell Inc., one of the largest PC makers in the world. Attended Memorial High School.

DE MENIL, DOMINIQUE SCHLUMBERGER
(1908–1997)
Arts patron, philanthropist and civil rights activist. Married JOHN DE MENIL in 1931. Her family's oil equipment business, SCHLUMBERGER, moved them to Houston following World War II. She and her husband created the Menil Foundation and began supporting UST in 1954. Their modern European art collection—which included Abstract Expressionism, Dadaism, Minimalism and Pop Art—became the basis for the MENIL COLLECTION on a thirty-acre site adjacent to UST in MONTROSE. She led the UNIVERSITY OF ST. THOMAS Art History Department from 1964 to 1969. She commissioned architect RENZO PIANO to design the MENIL COLLECTION, which opened in 1987, and the CY TWOMBLY GALLERY, which opened in 1995. SCHLUMBERGER continues today as the world's largest oil field services company.

DE MENIL, JOHN
(1904–1973)
Local businessman and arts patron. Born Jean de Menil. Married DOMINIQUE SCHLUMBERGER DE MENIL in 1931. Moved to Houston after World War II. Commissioned architect PHILIP JOHNSON to design an International-style home in RIVER OAKS. The De Menils were major donors to a young UNIVERSITY OF ST. THOMAS and founded the Art Department there. Commissioned the nondenominational ROTHKO CHAPEL, which opened in

1971. The De Menils supported human and civil rights causes, including the DeLuxe Show in the FIFTH WARD, and dedicated the ROTHKO CHAPEL'S BROKEN OBELISK to Martin Luther King Jr.

DEMOLITION
An action that destroys part or all of an existing structure. A commonplace occurrence in Houston. The City of Houston can protect a structure or site with an owner-requested PROTECTED LANDMARK designation (or if the structure is within a HISTORIC DISTRICT).

DEPELCHIN CHILDREN'S CENTER
Kezia Payne DePelchin opened her "Faith Home" in 1892 on WASHINGTON AVENUE for unwanted and abandoned children. It moved into 2710 Albany in 1913 and to the current twelve-acre campus on Sandman Street at Memorial Drive in 1937. It began serving the African American community in 1939. It opened Houston's only nonprofit psychiatric hospital that specialized in children and adolescents.

DERRICK
Structural framework used to hold an oil drill.

DERRICK DOLLS
The cheerleaders for the HOUSTON OILERS.

DESTINY'S CHILD
An R&B group formed in 1990 in Houston by manager Mathew Knowles. Hit it big with the line-up of BEYONCÉ KNOWLES, Kelly Rowland and Michelle Williams. Sold more than 60 million albums. Disbanded in 2006.

DEVINE, LORETTA
(1949–present)
Houston native and Emmy-winning actor who was raised in ACRES HOMES and attended UNIVERSITY OF HOUSTON. Originated the role of Lorell Robinson in *Dreamgirls* on Broadway.

DE ZAVALA, LORENZO
(1788–1836)
Mexican politician, Texas colonizer, signer of the Texas Declaration of Independence, diplomat and interim vice-president of the REPUBLIC OF

TEXAS. After falling into BUFFALO BAYOU, he contracted pneumonia. Buried in Channelview.

DIESEL
The orange fox mascot of the DYNAMO soccer team.

DIRTY THIRD
A hip-hop nickname for the GULF COAST, derived from Dirty South and THIRD COAST.

DISASTROS
A mocking nickname of baseball team the ASTROS, typically employed during a poor performance in any given season. See also LASTROS.

DISCO GREEN
Nickname for DISCOVERY GREEN.

DISCO KROGER
A chain grocery store on Montrose Boulevard and Hawthorne known for its more flamboyant customers.

DISCOVERY GREEN
A twelve-acre Downtown city park opened in 2008 across from the GEORGE R. BROWN CONVENTION CENTER and created from a public-private partnership. Includes a playground, promenades for outdoor markets, fountains, dog runs, a performing arts stage and a seasonal ice skating rink. The Grove and the Lake House provide dining.

DIVERSEWORKS
Nonprofit contemporary arts organization dedicated to presenting original literary, performing and visual arts and strengthening the audience for contemporary art in Houston.

DJ SCREW
(1971–2000)
A late local hip-hop artist. Creator of the CHOPPED AND SCREWED technique. He produced and sold his own mixtapes. The Houston nickname "SCREWSTON" is based on the influence he had on the Houston hip-hop community.

DOME FOAM
Nickname for concession stand beer sold at the ASTRODOME.

DOMER
A supporter of the ASTRODOME.

DOME, THE
Nickname for the ASTRODOME.

DOOMSDAY WRESTLING
A group dedicated to intentionally comedic performances of violent and over-the-top wrestling matches, including colorful characters with elaborate costumes and backstories, operating since 2003. The kids eat it up like candy.

"DON'T EVER UNDERESTIMATE THE HEART OF A CHAMPION"
Spoken by Houston ROCKETS head coach RUDY TOMJANOVICH upon winning their second straight NBA Championship in 1995.

"DO-WHAT-NOW?!"
Slang spoken quickly in response to disbelief or in requesting clarification—less common lately.

DOWLING, DICK
(1838–1867)
Irish-born saloon owner, founding member of Houston's fire department and hometown Confederate hero following the BATTLE OF SABINE PASS. He was posthumously honored with Houston's first public monument, now in HERMANN PARK. Dowling Street and Tuam Street (his Irish birthplace) are named for him.

DOWN IN HOUSTON: BAYOU CITY BLUES
Book by Roger Wood detailing the Houston blues scene from the mid-twentieth century to the present, published in 2003.

DOWNSTREAM
The division of the OIL AND GAS industry dedicated to the refining of CRUDE OIL and processing of NATURAL GAS, as well as to the marketing of finished consumer products.

DOWNTOWN SPLIT
Nickname for SPUR 527 off the SOUTHWEST FREEWAY. A convenient entrance/exit into/from MIDTOWN.

DREAM SHAKE, THE
The signature move by Houston ROCKETS Hall of Famer HAKEEM OLAJUWON. A set of fakes and spin moves allowing the player to misdirect his opponent.

DREAM, THE
Nickname for UNIVERSITY OF HOUSTON and Houston ROCKETS Basketball Hall of Famer HAKEEM OLAJUWON.

DREDGING
Periodic deepening of THE SHIP CHANNEL, allowing it to grow to accommodate greater commercial traffic and larger ships.

DREXLER, CLYDE
(1962–present)
Basketball Hall of Famer. Attended Ross Sterling High School. Former member of UNIVERSITY OF HOUSTON's PHI SLAMA JAMA and the 1995 NBA Championship Houston ROCKETS. Olympic gold medal winner as a member of the U.S. Dream Team in 1992. Nicknamed THE GLIDE. His number, 22, is retired by the ROCKETS.

DROUGHT
Due to a strong La Niña weather pattern that lessened the winter storm track of 2011, Houston suffered an extremely rare, months-long drought in 2011 from January to November. As the ground dried up, the city suffered from near-constant water main breakings. Tens of millions of trees died, and heavily wooded places such as MEMORIAL PARK will take decades to recover.

DR34M
An apparel and lifestyle product line by HAKEEM OLAJUWON, with headquarters in the restored West Mansion in CLEAR LAKE, founded in 2012.

DRY
Leftover, early twentieth-century political deal that keeps the Houston HEIGHTS free of alcohol sales. See also LOCAL OPTION.

DUALLY
A pickup truck with dual or double rear wheels.

DUCHESNE ACADEMY OF THE SACRED HEART
Among Houston's most prestigious private college prep schools, Duchesne is a Catholic school for girls in grades pre-kindergarten through grade twelve. Its wooded campus opened in 1960 on Memorial Drive.

DYNAMO
Houston's Major League Soccer team. Moved from San Jose in 2005, with the first season in Houston at UNIVERSITY OF HOUSTON's Robertson Stadium in 2006. Originally named the Houston 1836, but Hispanic groups protested its possible reference to the Texas War of Independence from Mexico. The Dynamo moved into BBVA COMPASS STADIUM in 2012. Their fans are known as the TEXIAN Army.

EADO
Newly named, old neighborhood east of Downtown and north of the GULF FREEWAY, known for warehouses, Asian restaurants and BBVA COMPASS STADIUM. Named by contest in 2009. Originally a part of the THIRD WARD. Known as Chinatown in the 1980s and 1990s. Also known as East Downtown Houston.

EARLERS, THE
Nickname for the Houston OILERS, owing to the importance of EARL CAMPBELL in their successes in the late 1970s and early 1980s.

EAST END
Neighborhood between Downtown and the PORT OF HOUSTON known for its majority Hispanic population. Includes former site of HARRISBURG, which preceded the founding of Houston. Includes EADO, EASTWOOD, IDYLWOOD, NINFA'S, the ORANGE SHOW and the famed TELEPHONE ROAD.

EASTEX FREEWAY
US 59 north. As Houston's second freeway, the first section opened in 1953. Although the original was poorly designed, the current freeway is wide and the fastest free route from Downtown to BUSH INTERCONTINENTAL AIRPORT.

EASTHEIMER
Nickname for Elgin Street, which becomes WESTHEIMER in MIDTOWN. Coined by Laura Vincent in 2015.

EASTWOOD
Among Houston's first master-planned subdivisions. Opened in 1913 in the EAST END.

"EAT 'EM UP, COOGS!"
Fan cheer at UNIVERSITY OF HOUSTON.

EDGE CITY: LIFE ON THE NEW FRONTIER
A 1991 book by Joel Garreau that popularized the phrase "edge city"— he was describing new, standard urban communities that grew in former

suburbs and apart from an original central downtown, but they had many of the characteristics of a central business district. Houston intellectuals loved this book because it made Houston's SPRAWL look sexy.

EIGHTH WONDER OF THE WORLD, THE
Nickname for the ASTRODOME, used mistakenly by other so-called landmarks around the world.

ELDORADO BALLROOM
Former live music venue for blues, jazz and R&B, across the street from EMANCIPATION PARK in the THIRD WARD from 1939 to the early 1970s. Known as the "Home of Happy Feet," the Eldorado hosted major headliners like Ray Charles and Etta James. In 1999, PROJECT ROW HOUSES bought the building for an event space.

ELEANOR TINSLEY PARK
A section of BUFFALO BAYOU PARK east of Taft Street dedicated to former city council member ELEANOR TINSLEY in 1998. Site for the annual FREE PRESS SUMMER FEST.

ELGIN
Street in THIRD WARD and MIDTOWN, named for Jack Elgin. Street becomes Westheimer after it crosses Bagby Street. Pronounced "*el*-jin."

ELLINGTON FIELD
World War I Army Air Service airfield, opened in 1917 as a training facility near CLEAR LAKE. Currently used for commercial and military purposes, as well as, occasionally, NASA. In 2012, the space shuttle *Endeavour* stopped by on its way to its permanent home in California.

EMANCIPATION PARK
Purchased in 1872 by the African American community for a place to celebrate JUNETEENTH, led by REVEREND JACK YATES. The ten-acre site was acquired by the City of Houston in 1916 as a segregated park. Added a community center in 1939 designed by WILLIAM WARD WATKIN. Renovated in 1998. Includes basketball courts, tennis courts, sports fields, playground and swimming pool. In 2011, the City of Houston launched a $33 million campaign to update the park.

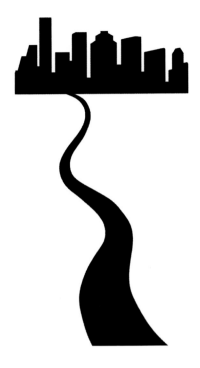

Houston Skyline.

EMERALD CITY
Nickname for the skyline view of Downtown Houston from BUFFALO BAYOU PARK, likened to that in the movie *The Wizard of Oz*.

EMPRESARIO
An entrepreneur given the right by Mexico to recruit settlers to move to Mexican Texas. See STEPHEN F. AUSTIN.

"END OF THE UNIVERSE, THE"
Place identified by comedian Lewis Black in 2001 where two Starbucks face each other on the corner of West Gray and Shepherd.

ENERGY CAPITAL OF THE WORLD
Nickname for Houston, from the thousands of oil, gas and energy companies headquartered here.

ENERGY CORRIDOR, THE
A business and residential community in West Houston, adjacent to the KATY FREEWAY and the Sam Houston Parkway, noted for its abundance of OIL AND GAS companies with headquarters there.

ENRON
A former leading energy trading company founded by KEN LAY. Driven to bankruptcy in 2001 through systematic accounting fraud in a deregulated energy market. Reaction to the scandal hastened the passage of 2002's Sarbanes-Oxley Act and the demolition of its accounting firm Arthur Andersen. President and CEO JEFF SKILLING and CFO Andrew Skilling saw jail time. KEN LAY died before a sentencing, which vacated his conviction. Subject of the documentary film *Enron: The Smartest Guys in the Room*.

ENSEMBLE THEATRE
Nonprofit repertory theater company and stage in MIDTOWN, founded in 1976 by George Hawkins and dedicated to promoting and preserving African American dramatic arts.

ESPERSON, MELLIE
(1870–1945)
Businesswoman and real estate developer who built Downtown's iconic Italian Renaissance–themed NIELS ESPERSON BUILDING in 1927, Texas's tallest structure up to that date. Opened the adjacent Mellie Esperson Building in 1941.

ESPLANADE
A physical, landscaped division down the length of prominent streets such as Heights Boulevard and Lovett Boulevard. Also known as a median.

EVENING STAR, THE
Novel sequel in 1992 to LARRY MCMURTRY's Houston-set TERMS OF ENDEARMENT; also a movie sequel in 1996 to the film version of TERMS OF ENDEARMENT, filmed in SOUTHAMPTON.

EYEOPENER TOURS
Sightseeing events hosted by THE ORANGE SHOW, where guests are taken to Houston's artistic, offbeat, weird or uncommon sites, operating since 1986.

FAJITAS
A TEX-MEX dish of grilled skirt steak wrapped in a tortilla in the tacos al carbon style and popularized by MAMA NINFA in the early 1970s. It can now include other meats.

FANCY PANTS
Better than General Admission tickets for FREE PRESS SUMMER FEST, including access to air-conditioned tents.

FARISH, WILLIAM STAMPS
(1881–1942)
OILMAN and philanthropist. Moved to Beaumont after oil was found at SPINDLETOP. Co-founded HUMBLE OIL AND REFINING COMPANY in 1917. Sold to Standard Oil Company in 1919. President of Standard Oil in 1937.

FATHER OF TEXAS, THE
Nickname for Anglo colonizer STEPHEN F. AUSTIN.

FEEDER ROAD/FEEDER
Where motor vehicles enter and exit freeways, highways and toll roads. Known elsewhere as frontage roads.

FERTITTA, TILMAN
(1957–present)
Local billionaire, businessman, restaurateur and philanthropist. Owner of Landry's Restaurants and Las Vegas's Golden Nugget Casino.

FIESTA
Chain grocery store founded in 1972. Known for serving traditionally underserved and Hispanic communities and allowing car-less patrons to take full shopping carts home.

FIFTH WARD
Former political district northeast of Downtown, created out of the FIRST WARD and SECOND WARD in 1866, running to the east of WHITE OAK BAYOU and to the north of BUFFALO BAYOU. Nicknamed THE NICKEL.

FINGER, JOSEPH
(1887–1953)
Prominent local architect known for designing Art Deco landmarks such as city hall, the 1940 Air Terminal at Houston Municipal Airport, LAWNDALE ART CENTER and many Jewish institutional buildings.

FINN, ALFRED C.
(1883–1964)
Local architect known for his work with many of the day's prominent Houstonians, including JESSE JONES, WALTER FONDREN, JOHN KIRBY, ROSS STERLING and SID WESTHEIMER—this made him Houston's leading commercial architect. Designed the GULF BUILDING, the San Jacinto Monument and Ezekiel Cullen Building at the UNIVERSITY OF HOUSTON.

FIRST MONTROSE COMMONS
Mostly residential neighborhood south of West Alabama, east of Montrose Boulevard and west of SPUR 27. Known for its early twentieth-century homes. HSPVA is in the district but is a non-contributing structure. HISTORIC DISTRICT since 2010.

FIRSTROS
Yet another nickname for the ASTROS. This one is a variation on "LASTROS" and *almost* never uttered.

FIRST WARD
Former political district defined by the corner northwest of Main Street and Congress Street. Established in 1840 as one of the first of the Houston WARDS, it was later divided to create the FIFTH WARD north of WHITE OAK BAYOU.

FISCHER, MAX
Misfit high school student in WES ANDERSON's 1998 movie RUSHMORE, played by Jason Schwartzman. He wrote a hit play and saved Latin.

FITZ
Nickname for bar FITZGERALD'S.

FITZGERALD'S
Former Polish dance hall built in 1918 on White Oak and Studemont. Sara Fitzgerald opened it as a bar and live music venue in 1977. A staple of the Houston music scene, Fitzgerald's has hosted up-and-coming acts as well as established acts, including James Brown, Daniel Johnston, R.E.M., the Ramones, Sonic Youth, Tina Turner, Stevie Ray Vaughan and ZZ TOP. Smaller, downstairs bar formerly known as Zelda's. PEGSTAR took it over in 2010. Also known as FITZ.

FLAT
Houston has little discernible topography.

FLOCK
The Houston Zoo young professionals group.

FLOWER MAN, THE
(1935–2013)
Nickname of THIRD WARD folk artist Cleveland Turner, who decorated his home and bicycle with flowers. By the time of his death, he had become an inspiring figure in Houston's art scene.

FM 1960
Multilane farm-to-market road that runs north of Houston, from CY-FAIR to I-45 North.

FOLEY'S
In 1900, James Foley and Pat Foley opened a dry goods store known as Foley Brothers. By 1922, it had become Houston's largest department store. Bought out by Federated Department Stores in 1947 and bought out again by May Department Stores in 1988, renamed Macy's in 2006.

FONDREN SOUTHWEST
A collection of southwest Houston residential and commercial neighborhoods around Fondren Road and BRAYS BAYOU.

FONDREN, WALTER
(1877–1939)
OILMAN, philanthropist and co-founder with ROSS STERLING of HUMBLE OIL COMPANY, later EXXON. Worked in the oil fields at SPINDLETOP. After moving to Houston, he bought into what would become TEXACO.

FOREMAN, GEORGE
(1949–present)
A former World Heavyweight Boxing Champion and Olympic gold medalist who grew up in the FIFTH WARD. A comeback in 1994 made him the oldest World Heavyweight Champion. He later had a successful post-boxing career as a spokesman for a countertop grill.

FOR THE SAKE OF THE SONG
A 2009 documentary film highlighting performers at ANDERSON FAIR, including Lucinda Williams, LYLE LOVETT and TOWNES VAN ZANDT.

FOSSIL FUELS
Formed by the decomposition of organic material and containing high concentration of carbon; includes PETROLEUM and NATURAL GAS.

FOSTER, MARCELLUS E.
(1870–1942)
Newspaper reporter and publisher. As a reporter for the *HOUSTON POST*, he covered SPINDLETOP and made a big chunk of change investing in it. He founded the *HOUSTON CHRONICLE* in 1901 with his oil profits and later partnered with JESSE JONES to finance expansion. Retired in 1927 but joined the daily newspaper *HOUSTON PRESS* in 1927 as editor. Nicknamed MEFO.

FOTOFEST
Local photography biennale and the first of its kind in the United States, founded in 1983 by documentary photographers and journalists Frederick Baldwin and Wendy Watriss and gallerist Petra Benteler. The first exhibition was held in 1986. Also features a year-round educational program, traveling shows, exchange programs and publications.

FOUNDERS MEMORIAL CEMETERY
Formerly the City Cemetery on West Dallas (formerly San Felipe Road).

FOUNDERS PARK CEMETERY
The final resting place for JOHN KIRBY ALLEN and other city founders, in
FREEDMAN'S TOWN, next to Beth Israel Cemetery.

FOURTH WARD
Former political district defined by the corner southwest of Main Street.
and Congress Street. Established in 1840 as one of the first of the Houston
WARDS, it was divided to create the SIXTH WARD out of the northern portion
above BUFFALO BAYOU. Included FREEDMEN'S TOWN and eastern parts of THE
MONTROSE. Nicknamed THE MOTHER WARD.

FOX, STEPHEN
Architectural historian, Houston history authority, teacher and author of
HOUSTON ARCHITECTURAL GUIDE.

FPSF
Abbreviation for the FREE PRESS SUMMER FEST.

FRACKING
The shortened version of HYDRAULIC FRACTURING, whereby pressurized fluid
is pushed through rock layer cracks and fractures in order to allow NATURAL
GAS to escape and be captured. Although around for more than one hundred
years, fracking was repopularized by GEORGE MITCHELL with his innovations
in horizontal extraction of natural gas. Largely responsible for the most
recent economic BOOM in Houston.

FRANCE
Looking for the Mississippi River, French explorer Robert de la Salle landed
at Matagorda Bay and established Fort Saint Louis, the first European
colony, albeit short-lived, in Texas.

FRANZHEIM, KENNETH
(1890–1959)
Architect who designed the Blaffer Memorial Wing at MFAH, the GULF
BUILDING and Downtown FOLEY'S state-of-the-art department store.

FREEDMEN'S TOWN

African American community in the FOURTH WARD settled by freed slaves in the late 1860s. A former thriving neighborhood of twenty-eight blocks with more than four hundred black-owned businesses, it slowly lost its distinctiveness and strength when projects such as the whites-only SAN FELIPE COURTS were built by the city's Housing Authority on one-quarter of taken land, or when the PIERCE ELEVATED freeway cut through its eastern border. Following desegregation, the African American community itself left for better neighborhoods, leaving older renters behind. Home to FOUNDERS PARK CEMETERY and Houston's first Jewish cemetery. In 1976, the National Park Service recognized forty blocks as a National Historic District, but with little implied protection. Developers have long hoped to use the land due to its proximity to Downtown and BUFFALO BAYOU PARK. A perfect example of how Houston neglects its own history. The Houston Public Library opened the African American Library at the Gregory School in 2009, and HISD opened the Carnegie Vanguard High School in 2012. Once also known as THE MOTHER WARD and Houston's Harlem.

FREELAND

Small residential neighborhood south of White Oak Drive and east of Heights Boulevard. Known for its modest early twentieth-century bungalows. HISTORIC DISTRICT since 2008.

FREEMAN, THOMAS

Legendary TSU debate coach. Taught Martin Luther King Jr. and BARBARA JORDAN. TSU Honors College is named for him.

FREE PRESS HOUSTON

Monthly, local, alternative, free newspaper highlighting arts, culture, music and politics with a Montrose-style attitude since 2003. Established and run by Omar Afra.

FREE PRESS SUMMER FEST

Annual weekend music festival in ELEANOR TINSLEY PARK, founded by *FREE PRESS HOUSTON* in 2009. Typically held in early summer, with a portion of the proceeds going to local nonprofits. Also known as FPSF.

FREEWAY
Slang for any highway, expressway or interstate inside the city. A popular term before Houston got toll ways.

FRENCHTOWN
A former Creole neighborhood within the Fifth Ward, founded in 1922.

FRENCHY'S
Popular and un-fancy, Creole-style fried chicken chain restaurant with a prominent location on Scott Street in the THIRD WARD, founded by the Creuzot family in 1969.

FREON
DuPont's trade name for chlorofluorocarbon, the organic compound that is used in refrigerants. Locally known as the stuff that keeps Houstonians cool year-round.

FRESH ARTS
Originally, a group of local arts organizations that promoted and advocated for the arts, founded in 2002. Merged with SPACETAKER in 2012, providing services to and resources for artists, as well as programs for the community. Hosts the annual WINTER HOLIDAY ART MARKET and a spring costume gala.

FRESH PAINT
An exhibition of local visual artists in 1985.

FRIDAY I'M IN LOVE
Independent documentary film on the history of NUMBERS nightclub, fully funded in 2015, from the Cure song of the same name. Written and directed by Marcus Pontello.

FRONTIER FIESTA
An annual student-run, cowboy-themed spring carnival at the UNIVERSITY OF HOUSTON to raise scholarship money, operating since 1940. Students and alumni build the temporary Fiesta City on campus for cook-offs, concerts and booths.

FROST TOWN

A former German settlement on BUFFALO BAYOU near the current McKee Street Bridge. Founded downstream from ALLEN'S LANDING by Jonathan Benson Frost in 1837.

FUQUA

A street in southeast Houston that is famously mispronounced. Preferred local pronunciation is "*fyoo*-kway."

FYHA

Abbreviation for "Fuck You, Houston's Awesome," a boastful, unapologetic local clothing line dedicated to putting Houston up, with a punk and hip-hop vibe, since 2010.

GAINES, GRADY
(1934–present)
Blues saxophonist and, in 1955, leader of the Upsetters, Little Richards's backing band, and later, Sam Cooke's band. Reformed as the Texas Upsetters in 1985.

GALLERIA, THE
Enclosed shopping mall on WESTHEIMER and LOOP 610 developed by GERALD HINES and opened in 1969, includes retail, dining, offices, ice skating, hotels and (formerly) two movie theaters. It was expanded to include Galleria II in 1977, Galleria III in 1983 and Galleria IV in 2002. Name is also used to describe the entire area.

GALLERY FURNITURE
A retail store founded by JIM MCINGVALE in 1981 "on I-45 North, between Tidwell and Parker" (as shouted by Mattress Mack) and in the GALLERIA area in 2009. Formerly, it featured only discount furniture.

GALLERY ROW
Two blocks of visual art galleries along Colquitt west of Kirby Drive.

GALLO, THE
Slang for the GALLERIA.

GALVESTON
Island city founded in 1839. It was once the most active port west of New Orleans and the largest city in Texas. Spanish explorer CABEZA DE VACA was shipwrecked there in 1528. City was named for Spanish colonial governor Bernardo de Gálvez by Jose de Evia upon mapping what is now GALVESTON BAY. Houston was well on its way to capturing Galveston's commercial shipping interests when a hurricane in 1900 took one-third of its population. Following the devastation, the entire city was raised eight feet, and a sea wall was built sloping back to the GALVESTON BAY. In the 1980s, city leaders led by native OILMAN GEORGE MITCHELL revived the long-dormant annual Mardi Gras celebration and rededicated themselves to restoring the historic Strand district. Galveston is also known as "Houston's beach."

GALVESTON BAY
Estuary between Galveston Island and the Texas mainland, fed by the San Jacinto River and the Trinity River, as well as by numerous bayous. Named by José Antonio de Evia for Spanish colonial governor Bernardo de Gálvez in 1786 when he was mapping the area. Eventually, the island and city took the name, too. As the path from the PORT OF HOUSTON's SHIP CHANNEL into the GULF OF MEXICO, the bay serves the area's oil and shipping industries.

GALVESTON ISLAND
The city of GALVESTON is on an island, connected to the mainland by the Galveston Causeway, the Bolivar Ferry or the San Luis Pass.

GALVO
Slang for GALVESTON.

GAMBLERS, THE
Houston's USFL football team from 1984 to 1985.

GAME OF THE CENTURY, THE
The first nationally televised college basketball game, between UNIVERSITY OF HOUSTON and UCLA in 1968 in the ASTRODOME.

G&G MODEL SHOP
A hobby shop opened in 1945 on Almeda. Moved to RICE VILLAGE in 1952. The oldest hobby shop in Texas.

GARDEN BOOK FOR HOUSTON AND THE TEXAS GULF COAST, A
A popular book first published in 1929 by WILL HOGG, now in its fifth edition, written by Lynn Herbert and sponsored by the River Oaks Garden Club.

GARRISON, ZINA
(1963–present)
Native Houstonian and pro tennis player who was a gold medal winner in the 1988 Olympics, a runner-up at Wimbledon in 1990 and a mixed doubles champion three times. Retired in 1996.

GAS
Shortened version of natural gas/gasoline.

GATOR, THE
Mascot of UNIVERSITY OF HOUSTON–DOWNTOWN.

GENERAL PLAN, THE
City vision plan from a committee organized by Mayor ANNISE PARKER and the Planning & Development Department in 2013 to ensure a coordination and collaboration throughout city departments and to build on existing plans in future projects. The Plan seeks to encourage development in areas of Houston that are lacking it.

GEOMETRIC MOUSE X
Claes Oldenburg 1971 sculpture in front of Downtown's Houston Public Library.

GEORGE R. BROWN CONVENTION CENTER
Convention center with over 1 million square feet on Downtown's eastern edge facing DISCOVERY GREEN, with an impressive skyline view. Opened in 1987 and expanded in 2003 with the opening of Houston's largest convention center hotel, the adjacent Hilton Americas and the TOYOTA CENTER.

GERMANTOWN
Small residential neighborhood adjacent to WOODLAND HEIGHTS since the 1880s, including Woodland Park. Houston's twentieth HISTORIC DISTRICT, approved by city council in 2012.

GETO BOYS
Houston's first nationally recognized hip-hop group, founded in 1986. Preceded the "Dirty South" sound. Current members include BUSHWICK BILL, SCARFACE and WILLIE D.

GIBBONS, BILLY
(1949–present)
Guitarist for ZZ TOP. Founded 1960s psychedelic band the Moving Sidewalks, which opened for Jimi Hendrix. Formed ZZ TOP in 1969, which soon included Frank Beard and Dusty Hill. Famous car collector and car customizer. Occasional TV actor and pitchman for FIESTA supermarkets.

GILLEY'S CLUB
Honky-tonk in PASADENA opened in 1971 by country-western singer Mickey Gilley and Sherwood Cryer. Made famous in the 1980 movie URBAN COWBOY. Once the world's largest honky-tonk. Closed in 1990 and reopened in 2003 in Dallas.

GIVE UP
Black-and-white wheat-paste poster public installations featuring the message "Give up" and razor blades.

GLASSELL SCHOOL OF ART, THE
The studio art and art history school of the MUSEUM OF FINE ARTS, HOUSTON, for both adults and children. Founded in 1978, housed in a glass brick building on Montrose Boulevard and named for Alfred C. Glassell Jr. Includes ceramics, digital imaging, drawing, jewelry, painting, photography, printmaking and sculpture. Home to the CORE PROGRAM.

GLASSTIRE
Nonprofit, online visual arts magazine covering Texas and Southern California since 2001, named for artist Robert Rauschenberg's sculptures of tires cast in glass.

GLENBROOK VALLEY
Residential neighborhood along Broadway Boulevard in northeast Houston since 1953. Known for its midcentury modern, ranch-style homes. HISTORIC DISTRICT since 2011.

GLENWOOD CEMETERY
Cemetery on WASHINGTON AVENUE, north of BUFFALO BAYOU PARK, since 1871. Final resting place for JOSEPH CULLINAN, WILLIAM STAMPS FARISH, GEORGE HERMANN, OVETA CULP HOBBY, WILLIAM P. HOBBY, ROY HOFHEINZ, HOWARD HUGHES JR., ANSON JONES, GLEN MCCARTHY and ROSS STERLING.

GLIDE, THE
Nickname for UNIVERSITY OF HOUSTON and Houston ROCKET CLYDE DREXLER.

G-MAN
Nickname for the Ginger Man bar in RICE VILLAGE, operating since 1985.

GOLDEN HANDSHAKE
A gesture to graduating medical students from the late Dr. Ralph Feigin, physician-in-chief of TEXAS CHILDREN'S HOSPITAL and chair of the Department of Pediatrics at BAYLOR COLLEGE OF MEDICINE, indicating acceptance into his residency program.

GOLD STAR RECORDS
Bill Quinn founded the Quinn Recording Company in 1941 and renamed the music label Gold Star Recording in 1950. Recorded LIGHTNIN' HOPKINS, George Jones, Sir Douglas Quintet, ROY HEAD, the MOVING SIDEWALKS and BJ THOMAS. Became SUGAR HILL RECORDING STUDIOS in the 1970s.

"GONE TO TEXAS"
This sign was posted on the abandoned homes of colonists who left their existing homes to move to Texas, see also GTT.

GONZO247
(1972–present)
Self-taught graffiti/spray-paint artist. Co-founder of AEROSOL WARFARE. Worked on documentary film *STICK 'EM UP*. Created the MARKET SQUARE mural on the exterior wall of TREEBEARD'S in 2013.

GOOD BRICK AWARDS
Annual recognition by the Greater Houston Preservation Alliance, now PRESERVATION HOUSTON, since 1979 for local contributions to preservation, restoration and Houston's architectural history. (Would it kill them to give one to Houstorian?)

GOODE, JIM
(1944–present)
Restaurateur who opened Goode Company in 1977 in a barn on Kirby, featuring beloved and award-winning BARBECUE, sides and PECAN PIE. Across the street, he opened a TAQUERIA and then a seafood restaurant. Next door, he opened the popular bar, party room and gift shop Armadillo Palace, which features all the embarrassing Texas stereotypes and a beloved giant ARMADILLO (with longhorns) sculpture facing the street.

GOODFELLOWS
A nonprofit community philanthropy group founded in 1912 by *HOUSTON CHRONICLE* city editor George Kepple, providing toys to needy Houston children. Goodfellows articles on families in need run throughout November and December in the *Chronicle*.

GOOF, THE
Acronym nickname for the greater Garden Oaks/Oak Forest neighborhood.

GO TEJANO DAY
An event scheduled into the HOUSTON LIVESTOCK SHOW AND RODEO, celebrating local Hispanic heritage and contributions to the community.

GO TEXAN DAY
The Friday before the HOUSTON LIVESTOCK SHOW AND RODEO's Parade, when Houstonians are encouraged to wear western/cowboy attire, running since the 1950s.

GRACKLE
Noisy, aggressive, ubiquitous black bird. Especially bothersome in May, when mothers become territorial and dive-bomb any pedestrian who comes close to the nest. Not to be confused with the crow, jackdaw, magpie or raven.

GRAND PARKWAY
The outer, outer loop that no one seems to want. The first segment opened in 1994. The proposed loop will be 170 miles when completed. Also known as State Highway 99.

GRAND PRIZE
Beer made by Gulf Brewing Company, founded by HOWARD HUGHES.

GRAND PRIZE
A MUSEUM DISTRICT bar. Formerly Ernie's on Banks.

GREATER HOUSTON PARTNERSHIP
Group dedicated to growing local economic prosperity and creating business-friendly initiatives. Formerly the Houston Chamber of Commerce, founded in 1840.

GREEK FEST, THE
Annual fall festival at the Annunciation Orthodox Cathedral in MONTROSE, operating since the 1960s.

GREEN SAUCE
Also known as *salsa verde*, served at TEX-MEX and Mexican restaurants, usually chilled, with chips; less spicy than accompanying red sauce.

GREENSHEET
A free, locally based seller/buyer, classifieds and business ads newspaper with issues focused by region, founded by Helen Gordon in 1970.

GREENWAY, AURORA
Fictional River Oaks widow in LARRY MCMURTRY's novel *TERMS OF ENDEARMENT*. Played by Shirley MacLaine in the movie version and its sequel, *THE EVENING STAR*.

GREENWAY PLAZA
Master-planned business development on the SOUTHWEST FREEWAY, between WEST U and RIVER OAKS. Opened in the late 1960s and includes THE SUMMIT (now LAKEWOOD CHURCH), a hotel and residential towers.

GREGORY INSTITUTE, THE
School founded in FREEDMEN'S TOWN in 1870 to educate the African American community. Joined HISD in 1876. Restored and reopened in 2009 to house the African American Library at the Gregory School, which serves as a resource for preservation, promotion and celebration of African American culture in Houston.

GROCERY WARS
The never-ending battle between major grocery store chains for dominance in the Houston market. Past and present combatants include Kroger, RICE EPICUREAN MARKET, Randall's, FIESTA, HEB and Whole Foods.

GROW HOUSE
Residence used for secretly growing marijuana. Once discovered, there is inevitably one neighbor who claims that they "knew all along something illegal was going on there."

G7
Also known as the WORLD ECONOMIC SUMMIT, held in Houston in 1990.

"GTT"
This sign was posted on the abandoned homes of colonists who left their existing homes to move to Texas, short for "GONE TO TEXAS."

GULF BUILDING
A landmark Downtown high-rise, the thirty-nine-story Art Deco office building was designed by ALFRED FINN and KENNETH FRANZHEIM and built by JESSE JONES in 1929. Stood as Houston's tallest skyscraper until 1963. Now known as the JPMorgan Chase Building.

GULF COAST
Land surrounding the GULF OF MEXICO. Also known as the THIRD COAST. Also a term for anything originating there.

GULF FREEWAY
Interstate 45, south of Downtown to GALVESTON. Houston's first freeway.

GULFGATE
Area named for nearby Gulfgate Mall, Houston's first, at the corner of the South Loop and the GULF FREEWAY.

GULF OF MEXICO
The major body of water southeast of Houston. Also known as the Gulf.

GUMBO
Nickname for Houston's native soil, also known as vertisol soil. Because of the shrinking and swelling clay just below the surface, it is notoriously difficult to build on.

GUNSPOINT
Nickname for Greenspoint area, at the intersection of the NORTH FREEWAY and Sam Houston Toll Road.

HAHC
Houston Archaeological and Historical Commission. Appointed-member board that reviews requests for HISTORIC DISTRICT designations, archaeological sites, landmarks and PROTECTED LANDMARKS. Issues CERTIFICATE OF APPROPRIATENESS. Makes recommendations to the city council on all potential historic properties.

HAIR BALL, THE
Costume gala by LAWNDALE ART CENTER, occurring every few years, known for over-the-top hair-themed costumes.

HALLIBURTON
Among the world's largest oil field services and energy services companies, with headquarters in Houston. Acquired BROWN & ROOT in 1962.

HAMILTON SHIRTS
Local upscale shirt-maker founded by Edward Hamilton and J. Brooke Hamilton in 1883.

HARDY TOLL ROAD
Twenty-two-mile toll road running from LOOP 610 North to the HARRIS COUNTY line, opened in 1988 and named for adjacent Hardy Street.

HARITHAS, ANN O'CONNOR
Former gallerist. Collage artist and co-founder of THE ART CAR MUSEUM and THE STATION MUSEUM. Early proponent of the ART CAR. Spouse of JIM HARITHAS.

HARITHAS, JIM
(1933–present)
Former director of THE CAM. He gave artist JULIAN SCHNABEL one of his first shows at the Cam. Proponent of the ART CAR. Co-founder of THE ART CAR MUSEUM. Co-founder and director of THE STATION MUSEUM. Spouse of ANN O'CONNOR HARITHAS.

HARRISBURG
Founded in 1825 by New York entrepreneur John Richardson Harris on BUFFALO BAYOU downstream from what would become Houston. SANTA ANNA burned the town in 1836. Annexed by Houston in 1926. Now a part of the EAST END.

HARRIS COUNTY
County that includes Houston, BAYTOWN, CLEAR LAKE, CY-FAIR, PASADENA and THE SHIP CHANNEL. Originally named Harrisburg County when it was founded in 1836. Renamed to avoid confusion with the small town.

HARRIS COUNTY FLOOD CONTROL DISTRICT
Created in 1937 to be the local partner with the Army Corps of Engineers. Empowered in 1996 to design and manage new federal flood damage reduction projects.

HARWIN
A street in southwest Houston with shops selling discount and fake designer goods.

HAUS
Houston Access to Urban Sustainability. A cooperative, sustainable housing project in Montrose, founded in 2011.

HAWC
Shortened version of Houston Area Women's Center.

HAYNES, RICHARD "RACEHORSE"
(1927–present)
Native Houstonian and dramatic criminal defense attorney. Alumnus of UNIVERSITY OF HOUSTON Law Center. Successfully defended Dr. John Hill and T. Cullen Davis in their respective murder trials.

HBU
Shortened version of Houston Baptist University, a Christian college founded in 1960 by the Baptist General Convention of Texas. Land developer Frank Sharp sold HBU the current site adjacent to his SHARPSTOWN. HBU opened in 1963.

HCC
Houston Community College System was founded by HISD in 1971, with multiple campuses operating in Houston, Missouri City, SPRING BRANCH and Stafford. The Central Campus is in MIDTOWN.

HCCC
Houston Center for Contemporary Craft is a nonprofit arts organization dedicated to educating about materials, processes and history of craft, with emphasis on clay, fiber, glass, metal, wood and found/recycled objects, since 1991. Its MUSEUM DISTRICT site includes exhibition, retail and studio spaces.

HEAD, ROY
(1943–present)
Singer/songwriter. Recorded the hit song "TREAT HER RIGHT" in 1965 at Houston's GOLD STAR STUDIOS (later renamed SUGAR HILL RECORDING STUDIOS).

HEDGES, THE
Landscaping that surrounds RICE UNIVERSITY. A symbolic wall, keeping students on campus.

HEIGHTS, THE
Nickname for the HOUSTON HEIGHTS.

HEIGHTS WAL-MART
Nickname by opponents of the Yale Street development south of THE HEIGHTS on a former industrial site, opened in 2012.

HERMANN, GEORGE
(1843–1914)
Native Houstonian, OILMAN and philanthropist who donated the land that is now HERMANN PARK and willed his estate to the City of Houston for the creation of HERMANN HOSPITAL. Buried in GLENWOOD CEMETERY.

HERMANN HOSPITAL
A former charity hospital funded from the estate of GEORGE HERMANN, opened in 1925.

HERMANN PARK
Signature public park with more than four hundred acres, designed by landscape architect George Kessler on land donated by MILLIONAIRE BACHELOR GEORGE HERMANN, opened in 1916. Adjacent to THE MEDICAL CENTER, RICE UNIVERSITY, THE MUSEUM DISTRICT and BRAYS BAYOU. Features include the SAM HOUSTON equestrian statue, MILLER OUTDOOR THEATER, McGovern Lake, McGovern Centennial Gardens, the Houston Zoo, the Japanese Garden, a kiddie train, a

reflecting pool, a public golf course (the first desegregated in the country) and hundreds of mature LIVE OAKS. Recently revitalized by planning and fundraising by the Hermann Park Conservancy.

HERSHEY, TERRY
(1921–present)
Conservationist and Buffalo Bayou Preservation Association founder. She led the fight to prevent the channelization of BUFFALO BAYOU. Terry Hershey Park is named in her honor.

HEUGEL, BOBBY
(1983–present)
Bartender and community activist who opened the artisanal cocktail haven ANVIL BAR & REFUGE on LOWER WESTHEIMER in 2009 and, later, Hay Merchant Craft Food & Beer and Underbelly Restaurant down the street. Founded OKRA in 2011 to promote, advocate and lobby for bar and restaurant causes and to support local charities. Since the founding of Anvil, he has been a key player in the bar restaurant community and a godfather to countless struggling enterprises.

HGO
Houston Grand Opera was founded in 1955 to enrich Houston through producing and performing opera, as well as supporting performances, community events and educational outreach. Moved into JONES HALL in 1966. HGO has debuted forty-seven world premieres and six U.S. premieres. Moved into THE WORTHAM in 1987.

HICKS, BILL
(1961–1994)
Stand-up comedian known for keen social commentary, experiments with mind-expanding drugs and philosophy. He attended Stratford High School and began his career at the COMEDY WORKSHOP on Shepherd. *FREE PRESS* succeeded in raising money to honor him with a statue, but a location has not been decided.

HICKS, JACKSON
(1946–present)
Local caterer, party planner and exclusive service provider for Downtown's THE CORINTHIAN. Learned customer service from Texas retailer Stanley

Marcus. Founded Jackson and Company in 1981, which later went national with food service company Aramark. Dubbed the "Prince of Parties."

HIDEOUT, THE
Smaller, late-night concert series hosted by RODEOHOUSTON, with up-and-coming performers playing in a tent after that night's main show.

HIGHLAND VILLAGE
Upscale, strip shopping center on WESTHEIMER, east of THE GALLERIA, adjacent to RIVER OAKS. Opened in 1957.

HILL, RAY
(1940–present)
Gay rights advocate and former host of KPFT's *The Prison Show*, which he started in 1980.

HILL, THE
Uncovered seating/picnic area at MILLER OUTDOOR THEATER. Generations of Houston children have rolled down it during performances there. A topographic oddity in flat Houston.

HINES, GERALD D.
(1925–present)
Real estate developer responsible for constructing iconic Houston landmarks such as the Bank of America building, CHASE TOWER, THE GALLERIA, ONE SHELL PLAZA, PENNZOIL PLACE and TRANSCO TOWER. Starting in 1957, he brought marquee-name architects to Houston, including PHILIP JOHNSON and I.M. Pei. Hines is now among the largest real estate companies in the world. UNIVERSITY OF HOUSTON's College of Architecture and the WATER WALL at TRANSCO are named in his honor.

HISD
Houston Independent School District. The local school district established informally in 1880s and founded in 1920s.

HISTORIC DISTRICT
Area designated by city council that holds a significance concentration of historic structures. Once designated, design guidelines may apply. Existing Historic Districts include AUDUBON PLACE, AVONDALE (East and West), BOULEVARD OAKS, BROADACRES, COURTLANDT PLACE, FIRST

MONTROSE COMMONS, FREELAND, GERMANTOWN, GLENBROOK VALLEY, HOUSTON HEIGHTS (East, South and West), MAIN STREET MARKET SQUARE, NORHILL, OLD SIXTH WARD, SHADOW LAWN, WEST 11TH PLACE, WESTMORELAND and WOODLAND HEIGHTS.

HIT THE BARRELS
Slang for a collision with a FREEWAY barrier, where barrels are employed to minimize damage in wrecks.

HIWI
"Houston. It's Worth It." Occasionally cheeky, always clever, independent ad campaign by Ttweak founders Dave Thompson and Randy Twaddle in 2004 to promote Houston, in spite of the city's well-known shortcomings. Produced books *HIWI:Ike* and *HIWI:Rice*. Can be pronounced "*high*-why."

HMRC
Shortened version of the HOUSTON METROPOLITAN RESOURCE CENTER.

HOBBY
Houston's first municipal airport. Originally started as a private airfield in 1927. Bought by the City of Houston in 1937. Named for Governor WILLIAM P. HOBBY in 1967. Uses airport code HOU. Home to the Art Deco landmark 1940 Air Terminal Museum.

HOBBY CENTER FOR THE PERFORMING ARTS
Built in 2002 in Downtown's THEATER DISTRICT for traveling stage productions. Includes Sarofim Hall, Zilkha Hall and the restaurant Artista. Home to TUTS. Not to be confused with craft store Hobby Lobby.

HOBBY, OVETA CULP
(1905–1995)
Wife of Governor WILLIAM P. HOBBY and mother of Lieutenant Governor Bill Hobby. Former president and publisher of the *HOUSTON POST*. The first commanding officer of World War II's Women's Army Auxiliary Corps. Appointed by President Eisenhower as the first secretary of the Department of Health, Education and Welfare (renamed Health and Human Services). The first HOUSTONIAN to be featured on a U.S. postage stamp.

HOBBY, WILLIAM P.
(1878–1964)
Governor of Texas and husband of OVETA CULP HOBBY. Chairman of the HOUSTON POST Company and owner of radio and television stations KPRC. HOBBY Airport is named in his honor.

HO CHI MINH TRAIL
A bike trail deep in the woods of MEMORIAL PARK, known for its dangerous twists.

HOFHEINZ PAVILION
UNIVERSITY OF HOUSTON indoor sports arena that opened in 1969. Home of PHI SLAMA JAMA, the ROCKETS before THE SUMMIT opened and rock concerts, including acts such as Elvis Presley, the Rolling Stones, Led Zeppelin, Prince and Madonna. Named in honor of ROY HOFHEINZ's wife, Irene Hofheinz. The basketball court is named in honor of GUY V. LEWIS.

HOFHEINZ, ROY
(1912–1982)
Politician, developer and former COUNTY JUDGE. Former mayor. Through the Houston Sports Authority, he helped bring Major League Baseball to Houston with the expansion team the COLT .45S (renamed the ASTROS). Dreamed up, built and ran the ASTRODOME, where he lived in a luxury apartment. Expanded the site into the ASTRODOMAIN, which included the AstroHall and ASTROWORLD. Majority owner of the Astros until bankruptcy forced him to sell the team. Nicknamed "THE JUDGE."

HOGG, IMA
(1882–1975)
Daughter of Texas governor Jim Hogg. She created a high standard for philanthropy, civic engagement and preservation in Houston. She organized the Houston Symphony Orchestra in 1913. She filled her RIVER OAKS home BAYOU BEND with art and antiques, and it became a museum in 1966. Known as "Miss Ima" and "the First Lady of Texas."

HOGG PALACE LOFTS
A former office building from 1921, it was among the first residential lofts in Downtown when it was converted in 1995.

HOGG, WILL
(1875–1930)
Son of Governor Jim Hogg and brother to IMA HOGG. Following his father's death, he moved to Houston and worked for JOSEPH CULLINAN of TEXACO. He was an advocate for ZONING and the beautification of Houston and developed RIVER OAKS. He published *A GARDEN BOOK FOR HOUSTON AND THE TEXAS GULF COAST* in 1929.

HOLCOMBE, OSCAR
(1888–1968)
Self-made millionaire. He was the longest-serving Houston mayor—twenty-two years, but not all consecutive terms. Portions of Bellaire Boulevard were renamed Holcombe Boulevard in his honor.

HONG KONG CITY MALL
The 150,000-square-foot market on Bellaire Boulevard, specializing in all Asian nationalities since 1999.

HONORS COLLEGE, THE
College within the UNIVERSITY OF HOUSTON with emphasis on teaching and learning.

"*HOO*-STON"
Incorrect pronunciation by General Zod in *Superman II*. "So this is Planet *Hoo*-ston?"

HOPKINS, LIGHTNIN'
(1912–1982)
World-renowned blues guitarist who made the THIRD WARD his home in the 1940s. Recorded for GOLD STAR RECORDS.

HORSES
Houstonians do not ride them to work, but the mayor usually rides one during the RODEO PARADE.

HOT BAGEL SHOP
A grungy NEARTOWN bagel store since 1984. It is considered to have the best bagels inside THE LOOP.

HOTEL OCCUPANCY TAX
The State of Texas empowers the City of Houston to collect this tax from hotel room rentals. Then the city distributes the money to the HOUSTON ARTS ALLIANCE, Harris County–Houston Sports Authority and various cultural programs. In Houston, 6 percent is taken for the state, 7 percent is taken for the city and 2 percent is taken for HARRIS COUNTY.

"HOT ENOUGH FOR YOU?"
Unfunny, ironic line spoken by a NEWSTONIAN during any hot day. Houstonians are allowed to smirk in response.

HOU
Airport code of HOBBY AIRPORT. Also, abbreviation for anything Houston.

HOUSE OF DERÉON
Media center and party venue owned by BEYONCÉ Knowles and mother Tina Knowles in MIDTOWN, named after Tina Knowles's mother; also, their fashion line.

HOUSE OF GUYS
Nickname for the all-night diner House of Pies, Kirby location.

HOUSTON ARCHITECTURAL GUIDE
Architectural historian STEPHEN FOX's indispensable 1990 guidebook that thoroughly catalogues all of Houston's existing and recently demolished architecturally significant structures and sites. Created as a project of the American Institute of Architects. Coined the term "AMNESIA" as the pervasive local ailment. The third edition was published in 2012. A great resource for Houston history.

HOUSTON ARTS ALLIANCE
A nonprofit organization founded in 2006 to support and promote arts through programs, artist grants and aid to other arts groups, from HOTEL OCCUPANCY TAX revenue. HAA manages the City of Houston's art collection and commissions new public art.

HOUSTON ARTS & MEDIA
A nonprofit organization dedicated to producing documentary films and books, with an emphasis on local history. Founded by Mike Vance in 2005.

HOUSTON CENTER FOR PHOTOGRAPHY
A nonprofit visual arts organization founded in 1981, dedicated to increasing understanding and appreciation of photography and providing classes, exhibits, programs and services to professional and amateur photographers. HCP has published the magazine *Spot* since 1982. Moved to its current MUSEUM DISTRICT site in 2006.

HOUSTON CHRONICLE
Currently, Houston's only daily newspaper, founded in 1901 by *HOUSTON POST* reporter MARCELLUS FOSTER. In 1908, he partnered with JESSE JONES, who later bought out Foster. The newspaper took some support from the HOUSTON ENDOWMENT until 1987, when the Hearst Corporation bought it.

HOUSTON ENDOWMENT
Philanthropic foundation established and funded by MARY GIBBS JONES and JESSE H. JONES in 1937.

HOUSTON FIRST
Local government corporation founded in 2011, maintaining and operating the city's convention, arts and entertainment venues, including MILLER OUTDOOR THEATRE, THE WORTHAM CENTER, GEORGE R. BROWN CONVENTION CENTER, JONES HALL and the convention center hotel.

HOUSTON HEIGHTS, THE
Founded as an independent community northwest of Downtown in 1891 by the Omaha and South Texas Land Company. Named for its elevation twenty-three feet above Downtown. Annexed by Houston in 1919, it has opted to remain DRY to date. Toward the end of the twentieth century, the Heights had become run-down from its lapsed deed restrictions. Since the 1990s, the Heights has seen a building boom, with restoration and new construction trying to

Heights Theater.

mimic the existing Victorian homes. "The Heights" is a term used to include adjacent neighborhoods such as FREELAND, NORHILL, WOODLAND HEIGHTS and GERMANTOWN. Houston Heights West was designated a HISTORIC DISTRICT in 2007, Houston Heights East was designated a HISTORIC DISTRICT in 2008 and Houston Heights South was designated a HISTORIC DISTRICT in 2011.

HOUSTON HISTORY
A triannual local history and culture magazine published by UNIVERSITY OF HOUSTON's Center for Public History since 2003.

HOUSTONIA
A dynamic and optimistic, Houston-centric magazine launched in April 2013.

HOUSTONIAN
A resident of Houston, Texas.

HOUSTONIAN HOTEL, CLUB & SPA, THE
Upscale fitness club and hotel on an eighteen-acre wooded site adjacent to MEMORIAL PARK and BUFFALO BAYOU since 1980.

"HOUSTON IS AN EXAMPLE OF WHAT CAN HAPPEN WHEN ARCHITECTURE CATCHES A VENEREAL DISEASE."
Quotation from architect Frank Lloyd Wright in 1954.

HOUSTON KID, THE
A 2001 album by local singer/songwriter RODNEY CROWELL.

HOUSTON LIVESTOCK SHOW AND RODEO, THE
The largest annual livestock exhibition in the world, typically beginning in March and running for twenty days. It always includes musical acts and first debuted in 1931 as the Houston Fat Stock Show (renamed in 1961). Also known as THE RODEO. Provides scholarships from its auctions, sponsors and ticket sales. Site of "THE COOKOFF."

HOUSTON MATTERS
Topical call-in and discussion radio show on KUHF 88.7 FM since 2013.

HOUSTON METROPOLITAN RESEARCH CENTER
A division of the Houston Public Library in the JULIA IDESON BUILDING (the former main branch building), which is home to archives, documents,

manuscripts, Houston and Texas history and special collections, opened in 1976. Restored and expanded in 2012. Also known as **HMRC**.

HOUSTON PLAN, THE
Congressman TOM BALL's proposal that Houston and the federal government share the cost for DREDGING a deep-water channel to Houston in what would become THE SHIP CHANNEL in 1914.

HOUSTON POST
A former newspaper founded in 1880, combined with the *TELEGRAPH AND TEXAS REGISTER* and sold in 1884. The revived name was used in a new newspaper in 1885. Run by the WILLIAM HOBBY and OVETA CULP HOBBY from 1939 until the 1990s. Ceased publication in 1995.

HOUSTON PRESS
Weekly alternative newspaper since 1989, founded by JOHN WILBURN. Former daily newspaper from 1911 until it was sold to the HOUSTON CHRONICLE in 1964.

HOUSTON PROUD
PR campaign from the Houston Economic Development Commission to promote the city in 1986.

HOUSTON PUBLIC MEDIA
Formerly Houston PBS, rebranded in 2014 and includes 88.7FM, Classical 91.7FM and KUHT-TV.

HOUSTON REVIEW, THE
Research magazine published by the Houston Public Library beginning in 1979.

HOUSTON, SAM
(1793–1863)
Arguably the most important political and military leader in all of Texas's history. Lived with the CHEROKEES as a teen. Fought against the British in 1813. Indian rights advocate. Resigned as governor of Tennessee and gained Cherokee citizenship. Came to Texas in 1832. Shrewd yet emotional leader of the TEXIAN ARMY who led them to victory at the BATTLE OF SAN JACINTO. First elected president of the REPUBLIC OF TEXAS. Held nuanced

Sam Houston Statue.

opinions about slavery and fought to preserve the Union. First governor of the State of Texas. The city of Houston was named for him by the ALLEN BROTHERS, although he never had a permanent residence there. Kept a permanent residence and died in HUNTSVILLE. The only person to be governor of two U.S. states. Nicknamed THE RAVEN, COLONNEH, BIG DRUNK, OLD SAM JACINTO and OLD CHIEF.

HOUSTON'S HOT
A roundly mocked PR campaign generated to promote Houston during the 1990 Economic Summit.

HOUSTON TOMORROW
A nonprofit founded by David Crossley in 1998, dedicated to improving quality of life through planning, research and education. Formerly the Gulf Coast Institute.

"HOUSTON, TRANQUILITY BASE HERE. THE EAGLE HAS LANDED."
The first words broadcast from the moon by APOLLO 11 ASTRONAUT Neil Armstrong on July 20, 1969.

"HOUSTON, WE HAVE A PROBLEM."
Quotation and tagline from 1995 movie *APOLLO 13*. It is a variation on original NASA mission Apollo 13 line, "Okay, Houston, we've had a problem here" by Jack Swigert Jr. and, later, Jim Lovell, on April 14, 1970. To this day, the quotation is reused constantly, in any context, and usually with bad variations and/or groan-worthy puns.

"HOW-STON"
New York City pronunciation of its own Houston Street.

HSPVA

High School for the Performing and Visual Arts. A MONTROSE-area HISD public school for dance, theater, instrumental music, vocal music, creative writing and visual arts. Students are required to audition for entrance. A new Downtown campus broke ground in 2014.

H, THE

Nickname for Houston.

H-TOWN

Houston nickname, from Houston-Town, first popularized in the 1990s.

HTX

A new, less common abbreviation and nickname for Houston ripped off from Austin's ATX. Typically favored by NEWSTONIANS who don't know any better.

HUGHES, HOWARD, JR.

(1905–1976)

Houston native. Industrialist, inventor, movie producer and aviator. Inherited his father's oil equipment business, HUGHES TOOL COMPANY, in 1924. Attended RICE INSTITUTE for a short time. Buried at GLENWOOD CEMETERY. The municipal airport was briefly named for him.

HUGHES TOOL COMPANY

OILMAN Howard Hughes Sr. created the innovative cone-shaped drill bit, which transformed how oil wells were drilled, and he eventually owned dozens of drill bit patents. Run by HOWARD HUGHES JR. in 1924. Merged with Baker Oil Tools in 1987 to form Baker Hughes.

HUMBLE

The city of Humble was founded in the mid-1800s by Pleasant Smith Humble northeast of Houston. Known for its timber sawmills and oil reserves. By 1905, it had the largest producing oil field in Texas. Now mostly a commuter suburb. Pronounced "UMBLE."

HUMBLE OIL AND REFINERY COMPANY

Co-founded by ROSS STERLING and WILLIAM FARISH in 1911, later sold to Standard Oil Company in 1919. Produced the first OFFSHORE DRILLING well in Texas.

HUMIDITY
Water vapor in the air. Houston's prevailing climate characteristic. All Houstonians judge their relative comfort on the level of the current humidity.

HUNKER DOWN
During a HURRICANE, this is the alternative to evacuation. Also known as "shelter-in-place." The term was popularized during the slow approach of HURRICANE IKE in 2008.

HUNTINGTON, THE
Swanky, residential high-rise on Kirby Drive built across from River Oaks Elementary in 1983.

HUNTSVILLE
City north of Houston. Known for SAM HOUSTON's permanent residence and the state prison. Location of Texas's Death Row.

HURRICANE
Potentially catastrophic weather event known for damaging winds and rain along the GULF COAST and Atlantic Coast. Hurricane season runs from June to November.

HURRICANE FENCE
Also known as a chain-link fence.

HURRICATION
A vacation necessitated by an imminent HURRICANE, a party for those choosing to HUNKER DOWN during the storm or the time off from work during the storm.

HYDRAULIC FRACTURING
The act of pushing pressurized fluid through rock layer cracks and fractures in order to allow NATURAL GAS to escape and be captured. Although around for more than one hundred years, it was repopularized by GEORGE MITCHELL with his innovations in horizontal extraction of natural gas. Largely responsible for the most recent economic BOOM in Houston. Also known as FRACKING.

"*HYOO*-STON"

Most common, local pronunciation of Houston.

HYPA

Houston Young People for the Arts. Founded to promote performing and visual arts to young professionals. Later became a committee of the Houston Downtown Alliance (HDA), the parent organization of Houston's THEATER DISTRICT. Pronounced "*high*-pah."

IAH
Code/abbreviation of BUSH INTERCONTINENTAL AIRPORT.

IBP
Infernal Bridegroom Productions, a defunct theater group that led to the formation of the CATASTROPHIC THEATRE. Actor JIM PARSONS is a former member of IBP.

ICE HOUSE
Indigenous bar type without an interior but with plenty of picnic benches, as well as different operating rules from a typical bar. Evolved from country grocery stores where customers would buy large blocks of ice. See WEST ALABAMA ICE HOUSE.

ICE SKATING
An activity generally occurring indoors, with notable exceptions at DISCOVERY GREEN at Christmastime. See THE GALLERIA.

IDEAL X
The first CONTAINER SHIP, arrived at the PORT OF HOUSTON on its maiden voyage in 1958.

IDESON, JULIA
(1880–1945)
Librarian, activist and advocate for Houston Public Library. The 1926 Central Library Building was renamed in her honor.

IDYLWOOD
Residential, deed-restricted neighborhood in the EAST END adjacent to BRAYS BAYOU, developed in the 1930s.

IFEST
Houston International Festival was founded in 1971 as Downtown's Main Street 1, "A Salute to the Arts." Renamed the Houston Festival in 1976 and Houston International Festival in 1987. Co-produced Houston's first ART CAR PARADE with THE ORANGE SHOW in 1987. Evolved into a two-week event

celebrating performing and visual arts, typically spotlighting a different nation each year, ended in 2014.

"IF YOU CAN'T DO THIS, GET OUT OF THE BUSINESS!"
David Letterman's praise for THE SUFFERS following their national television debut in 2015.

"IF YOU EVER GO TO HOUSTON"
A 2009 Bob Dylan song with the lyrics: "If you're ever down there on Bagby and Lamar/You better watch out for the man with the shining star/Better know where you're going or stay where you are/If you're ever down there on Bagby and Lamar."

IKE
Catastrophic hurricane that struck Galveston and Houston in 2008. The costliest hurricane to strike Texas.

IKE DIKE
A proposed $4 to $6 billion storm surge control device outside GALVESTON BAY to protect THE SHIP CHANNEL.

IMPERIAL SUGAR
A national sugar producer located in the former sugar cane plantation, now known as SUGAR LAND, established in 1843. Got its current name when the company was bought by Galveston's Kempner family in 1907.

INDEPENDENCE HEIGHTS
The first independent African American municipality in Texas. Founded in 1908 north of the HOUSTON HEIGHTS and annexed by the City of Houston in 1929.

INLINE SWINE
A so-called "Friendly," MONTROSE-area skating group founded in 1992.

INNER LOOPER/LOOPER
Person who resides inside THE LOOP.

INNERVIEWS
A local, unscripted interview program on Channel 8 since 2004, hosted/produced by Ernie Manouse.

INPRINT
A literary arts nonprofit committed to inspiring readers and writers in Houston since 1983. Generously supports UNIVERSITY OF HOUSTON's Creative Writing Program and hosts lectures, reading and workshops through its Inprint Brown Reading Series.

INTERNATIONAL STYLE
A Modernist architectural style developed in Europe in the 1920s and popularized in the United States by PHILIP JOHNSON. In 1932, he sought to showcase buildings that expressed volume over mass and rejected ornamental features. Johnson based some of his Houston skyscrapers on this style.

"IN TIME"
Motto of the UNIVERSITY OF HOUSTON, adopted in 1938.

IRON FORK
Competition of Houston's new and established chefs at the annual MENU OF MENUS, since 2012.

ISLAND, THE
Nickname for GALVESTON in general and GALVESTON ISLAND specifically.

ITCHY ACRES
Name for the outside-the-LOOP artists' community, coined by Carter Ernst and Paul Kittelson in 1989, adjacent to ACRES HOMES. Home to the ART GUYS' headquarters.

IVINS, MOLLY
(1944–2007)
Beloved, outspoken and opinionated journalist and author specializing in politics. She was raised in Houston and graduated from ST. JOHN'S SCHOOL. She is credited for creating the George W. Bush nickname SHRUB.

JACK
Nickname for pranks by RICE UNIVERSITY students.

JACKSON LEE, SHEILA
(1950–present)
Former city council member and current Congressional Representative for Houston's Eighteenth District. The nationally known Democrat is famous for her outspoken personality.

JAMAIL, JOE
(1925–present)
Billionaire Houston attorney and philanthropist, known as KING OF TORTS after his big win in *TEXACO V. PENNZOIL*. Attended the UNIVERSITY OF ST. THOMAS.

JAWORSKI, LEON
(1905–1982)
Lawyer and special prosecutor in the Watergate scandal. Named partner in the law firm Fulbright & Jaworski.

JCC
The Jewish Community Center on BRAYS BAYOU, built in 1969.

JCI
Local hotdog restaurant chain James Coney Island, opened in 1923.

JETERO
Former street name of Will Clayton Parkway in northeast Houston adjacent to HOUSTON INTERCONTINENTAL AIRPORT. A variation on "Jet Era."

JIMENEZ, LUIS
(1940–2006)
Sculptor who focused on Hispanic themes and iconography. Taught at UNIVERSITY OF HOUSTON. Known for his colorful sculpture *Vaquero* in MOODY PARK.

JOHNSON, CONRAD "PROF"
(1915–2008)
Musician, music teacher and founder of the innovative KASHMERE STAGE BAND at Kashmere High School.

JOHNSON, LYNDON B.
(1908–1973)
U.S. president. Lived in WESTMORELAND in 1930 when he taught at Downtown's former Sam Houston High School. As a U.S. senator, he worked with local congressman ALBERT THOMAS to locate NASA's MANNED SPACECRAFT CENTER in CLEAR LAKE, where its campus was named in his honor in 1973. Mentor to BARBARA JORDAN.

JOHNSON, PHILIP
(1906–2005)
World-renowned architect with major contributions to Houston. Friends JOHN and DOMINIQUE DE MENIL hired him to design their Houston residence and later invited him to design the campus of the UNIVERSITY OF ST. THOMAS. Other notable projects in Houston include PENNZOIL PLACE, the Bank of America Center (Republic Bank Center), TRANSCO TOWER, GERALD HINES College of Architecture at the UNIVERSITY OF HOUSTON and the Chapel of St. Basil.

JOHNSON SPACE CENTER
NASA established JSC in 1961 as the MANNED SPACECRAFT CENTER in CLEAR LAKE. Renamed in honor of President LYNDON JOHNSON in 1973. Home to MISSION CONTROL, where all of NASA's spaceflight coordination is controlled and monitored, including for the International Space Station. Construction site of the Orion Multi-Purpose Crew Vehicle to transport astronauts into deep space. JSC is responsible for astronaut training and much scientific and medical research. SPACE CENTER HOUSTON was created in 1992 to showcase NASA and other science, as well as kid-friendly, quasi-science exhibits.

JOLLY SCIENCE
Nickname for *La Jaliscience*, the former Mexican restaurant on Montrose Boulevard.

JONES, ANSON
(1798–1858)
Physician, congressman and the last president in the REPUBLIC OF TEXAS. As president, he held out for recognition of independence from Mexico, despite public pressure to forget it and accept annexation by the United States. Jones got the treaty, but Congress rejected it. He committed suicide in Houston and is buried at GLENWOOD CEMETERY.

JONES HALL
The JESSE H. JONES Hall for the Performing Arts opened in 1966 as a gift from the HOUSTON ENDOWMENT to the City of Houston. It was home to the Houston Ballet and the HOUSTON GRAND OPERA until 1987, when the WORTHAM CENTER opened. Continues as the home of the Houston Symphony and the SOCIETY FOR THE PERFORMING ARTS.

JONES, JESSE H.
(1874–1956)
Lumber industrialist, real estate developer, banker and philanthropist. Builder of Houston's first skyscrapers. One-time owner of the *HOUSTON CHRONICLE*. Helped pay for THE SHIP CHANNEL. Helped land the Democratic National Convention in 1928. Appointed to the Reconstruction Finance Corporation, which became the nation's leading financial institution during the Great Depression. President Franklin Roosevelt appointed him the secretary of commerce. Established the HOUSTON ENDOWMENT in 1937. Member of the SUITE 8-F group. Also known as "MR. HOUSTON."

JONES, MARY GIBBS
(1872–1962)
Philanthropist and wife of JESSE JONES. Co-founder of the HOUSTON ENDOWMENT. She endowed the first women's dormitory Jones College at RICE UNIVERSITY.

JONES PLAZA
The central one-block park in Downtown's THEATER DISTRICT, opened in 1966 and remodeled in 2001. Site of PARTY ON THE PLAZA.

JORDAN, BARBARA
(1936–1996)
Native Houstonian and politician. Grew up in the FIFTH WARD. Attended TSU. First African American woman in the Texas Senate since Reconstruction.

First African American woman from the South to serve in the U.S. Congress, representing the Eighteenth District from 1973 to 1979. She was a champion of the disenfranchised and an advocate for all Houstonians. Former president LYNDON JOHNSON was a friend and political mentor, Governor Jimmy Carter considered inviting her to be his running mate and President Bill Clinton discussed nominating her to the Supreme Court. The second HOUSTONIAN to be featured on a U.S. postage stamp. Anyone who ever heard her knew in their bones that she communicated with authority and authenticity. She gave a voice to those without and spoke truth to power.

JSC
Short for JOHNSON SPACE CENTER.

JUAN CARLOS
Stage name for Juan Carlos Restrepo, the so-called MONTROSE ROLLERBLADE DANCER. A hairdresser who free-form dances on rollerblades at the intersection of Montrose Boulevard and Allen Parkway for the entertainment of commuters. Appeared on TV's *America's Got Talent* in 2014.

JUDGE, THE
Nickname for ROY HOFHEINZ, who served as HARRIS COUNTY JUDGE.

JUICE BOX, THE
Nickname for MINUTE MAID PARK, the Coca-Cola company famous for orange juice.

JULIA IDESON BUILDING
The Houston Public Library's home of the HOUSTON METROPOLITAN RESEARCH CENTER and THE TEXAS ROOM. Named for the legendary librarian JULIA IDESON. Built in 1926 and restored in 1979 and 2011. The common areas are used for private and public events.

JUNETEENTH
Annual June 19 holiday commemorating the announcement of the abolition of slavery, when news of the Emancipation Proclamation was read in GALVESTON by Union general Gordon Granger in 1865, nearly two years after it was issued. Houston's first Juneteenth celebrations were held in EMANCIPATION PARK. Juneteenth celebrations have since spread beyond Texas's borders.

Karbach
Local brewery on Karbach Street founded in 2011.

Kashmere Stage Band
Kashmere High school performing band, led by Prof Johnson from the late 1960s and nationally recognized for innovative contemporary funk and soul arrangements. Featured in the 2011 documentary film *Thunder Soul*.

Katrina
The 2005 hurricane that struck Louisiana and brought more than 150,000 evacuees to Houston; many relocated here permanently. Harris County opened the Astrodome as a temporary shelter to the evacuees.

Katy
City in west Harris County, incorporated in 1945 and named for the Missouri-Kansas-Texas Railroad (M-K-T, or K-T) that ran through it.

Katy Freeway
Interstate 10, west of Downtown, named for Katy, Texas.

Kay's Lounge
Among Houston's oldest bars, north of Rice University. It opened as a restaurant on Bissonnet in 1939.

"kay-true"
Pronunciation of defunct KTRU Rice University Radio. In its heyday, it was the best local place for college radio.

KBR
Kellogg Brown & Root engineering and construction company.

Keen, Robert Earl
(1956–present)
Houston native, country singer and songwriter. Attended Sharpstown High School and Texas A&M University, where he became friends with fellow musician Lyle Lovett.

KEGG'S CANDIES
Local confectionery since 1946.

KENNEDY BAKERY BUILDING
Reportedly Houston's oldest commercial building, from 1861. Home to LA CARAFE since 1961. Located in MARKET SQUARE.

KENNEDY, JOHN F.
(1917–1963)
U.S. president who delivered the "WE CHOOSE TO GO TO THE MOON" speech at RICE UNIVERSITY in 1962. He stayed at Downtown's RICE HOTEL the day before his assassination.

KETCHUP AND MUSTARD
Slang for the colors of the HOUSTON ROCKETS, based on their classic uniform colors red and yellow.

KICKER
Shortened version of SHIT-KICKER.

"KICK IT IN"
A shortened version of OILERS coach BUM PHILLIPS'S infamous quotation, "LAST YEAR WE KNOCKED ON THE DOOR. THIS YEAR WE BEAT ON IT. NEXT YEAR WE'RE GOING TO KICK THE SON OF A BITCH IN."

KING OF TORTS
Nickname for billionaire lawyer JOE JAMAIL.

KINGWOOD
Community north of Houston along US 59, originally owned by the King Ranch and developed in 1971 by the King Ranch and Exxon's Friendswood Development Company. In the mid-1990s, Kingwood residents fought against ANNEXATION by the City of Houston and lost. Also known as "THE LIVABLE FOREST."

KINKAID SCHOOL, THE
Houston's oldest coeducational private school (kindergarten through twelfth grade), founded in 1906 by Margaret Hunter Kinkaid. In 1957, it moved to its current campus in Piney Point Village. Notable alumni include JAMES BAKER III, George W. Bush and Jeb Bush.

KIRBY
Major north–south street connecting BUFFALO BAYOU PARK to the ASTRODOME at the South Loop. Named for the lumber industrialist John Henry Kirby.

KLINEBERG, STEPHEN
(1940–present)
Sociology professor at RICE UNIVERSITY. Founder of the Houston Area Survey, measuring the region's demographic and economic trends since 1981.

"KNOCK THREE TIMES"
Directions for entering the landmark bar and restaurant LAST CONCERT CAFÉ.

KNOWLES, BEYONCÉ
(1981–present)
Native Houstonian. Singer, dancer and actor who attended HSPVA. She hit the big time with R&B group DESTINY'S CHILD. She sang the national anthem at President Obama's Second Inauguration in 2013. She loves to name-drop Houston in her songs. Also known as BEYONCÉ, BEY and MISS 3RD WARD.

KOLACHE
Pastry of Czech and Slovak origins that came with European settlers to Central Texas. Found in many local doughnut shops, including SHIPLEY'S.

KPFT
Houston's community-supported Pacifica radio station, founded in 1970 at 90.1 FM. Subject to occasional acts of terrorism due to its progressive political views. Located in MONTROSE.

KPRC
Houston's first radio station, founded by WILLIAM P. HOBBY and ROSS STERLING and which first broadcasted in 1925. Stands for Kotton, Port, Rail Center. Its sister television station was born when the Hobby family bought exiting KLEE in 1950. The AM radio station is now owned by Clear Channel.

KUHL-LINSCOMB
Fancy-pants interior design firm whose building was transformed into an immense, multi-building, upscale lifestyle, design and retail store in UPPER KIRBY.

KUHT

The first public television station in the United States. Owned by UNIVERSITY OF HOUSTON. Also known as Channel 8 and HOUSTON PUBLIC MEDIA.

KUYKENDAHL

Street in northwest Houston, pronounced "*ker*-kin-doll." Pronunciation is the truest test of an actual HOUSTONIAN.

LA BARE
A notorious west Houston strip club catering to women since the early 1980s.

LA CARAFE
Dingy beer and wine bar in Houston's oldest commercial building, the KENNEDY BAKERY BUILDING, in MARKET SQUARE. Even though it opened in 1962, it is constantly mistaken for Houston's oldest bar.

"LA GRANGE"
Song by ZZ TOP from their 1973 album *Tres Hombres*, referring to the famed Chicken Ranch in La Grange, Texas, which was later "exposed" by reporter MARVIN ZINDLER and depicted in the play *THE BEST LITTLE WHOREHOUSE IN TEXAS*.

LAKE HOUSTON
Houston grew by 108 square miles when it annexed the territory along the SAN JACINTO RIVER, which was flooded to become this city reservoir in 1956.

LAKEWOOD CHURCH
A local mega-church with the largest congregation in the United States. The nondenominational services are led by the best-selling author and always-smiling pastor JOEL OSTEEN and his wife, Victoria Osteen. Moved into THE SUMMIT/COMPAQ CENTER in 2005 after extensive renovations. Grew out of televangelist John Osteen's Lakewood Baptist Church in northeast Houston.

LA MAFIA
A Grammy-winning Latin pop/TEJANO musical group from Houston's Northside, founded in 1980.

LAMAR BIKE LANE
Houston's first dedicated bike lane on Lamar Street, connecting BUFFALO BAYOU PARK to DISCOVERY GREEN, opened in 2015.

LAMAR, MIRABEAU B.
(1798–1859)
The second elected president of the REPUBLIC OF TEXAS. He moved to Texas in 1835 and served under SAM HOUSTON in the battle for Texas

independence, later becoming political rivals with him. Known as "the Father of Texas Education." He owned property in what is now Hyde Park. Lamar High School is named for him. Relocated the capital to Austin.

LA MEX
Nickname for La Mexicana restaurant in MONTROSE.

LANDMARK
Term for any historic and/or beloved building, but local ones are not protected unless they are designated PROTECTED LANDMARKS by City of Houston with the owner's request.

LA PORTE
A city on GALVESTON BAY founded in 1892. The location of the SAN JACINTO Battleground.

LAST CONCERT CAFÉ
Mexican restaurant north of Downtown, opened in 1949 by Elena "Mama" Lopez, who ran it until her death in 1985. The only marking is a red front door, which is always locked until a customer knocks three times for entry. Now a live music venue with a bar and backyard, as well as a popular destination of many acoustic musicians, jam bands and festivals. Designated as a PROTECTED LANDMARK in 2011. Also known as LCC.

"LASTROS"
Derogatory pun used to mock baseball team ASTROS' poor performance in any given season. See also DISASTROS.

"LAST YEAR WE KNOCKED ON THE DOOR. THIS YEAR WE BEAT ON IT. NEXT YEAR WE'RE GOING TO KICK THE SON OF A BITCH IN."
Then-shocking quotation from HOUSTON OILERS head coach BUM PHILLIPS upon their return to a pep rally in the ASTRODOME, following their heartbreaking second straight playoff loss on January 6, 1980.

LAURA
The first steamship to arrive at ALLEN'S LANDING, on January 22, 1837, proving that BUFFALO BAYOU was navigable for commercial traffic (as the ALLEN BROTHERS had claimed). This spurred near constant BUFFALO BAYOU

development, adjacent rail building, channel DREDGING and widening, ultimately growing THE SHIP CHANNEL into the major PORT OF HOUSTON.

LAURENZO, MARIA "MAMA" NINFA RODRÍGUEZ
(1924–2001)
Restaurateur, philanthropist and founder of NINFA'S. Popularized the dish fajitas and TEX-MEX cuisine. In 1973, she opened her now landmark NINFA'S in her tortilla factory on Navigation Boulevard in the EAST END.

LAWNDALE
Nickname for Lawndale Art Center, named for the street near its first location. Founded by artist JAMES SURLS in 1979 following a fire that relocated the UH Painting and Sculpture Department, after which it became independent from UH. Moved into the Art Deco Barker Brothers Building in MUSEUM DISTRICT in 1993.

LAY, KENNETH "KEN"
(1942–2006)
Former CEO and chairman of energy company ENRON. For his role in the collapse and bankruptcy of Enron, he was found guilty of conspiracy and securities fraud but died before he was to be sentenced.

LBJ
Nickname for LYNDON B. JOHNSON General Hospital, owned by the HARRIS COUNTY Hospital District, and a teaching hospital for University of Texas Medical School, serving mostly indigent patients.

LCC
Abbreviation for LAST CONCERT CAFÉ.

LEAN
Popular illegal drink, purple in color, consisting of Promethazine with codeine, Sprite and candy, usually served in a Styrofoam cup. Originated in Houston. Also known as PURPLE DRANK or SIZZURP.

LEANING
Local slang for being under the influence of drugs, especially the codeine-laced drink LEAN.

LELAND, MICKEY
(1944–1989)
Activist and former U.S. congressman from the FIFTH WARD. Succeeded BARBARA JORDAN in representing the Eighteenth District. The international terminal at BUSH INTERCONTINENTAL AIRPORT and the Mickey Leland Federal Building are named in his honor.

LEMONADE DAY
An organization that teaches children the fundamentals of business and demonstrates the same principles required to start any big company by helping them start, own and operate their own lemonade stand. Founded in Houston in 2007, now nationwide.

LEON'S LOUNGE
Formerly Houston's oldest bar. Founded in 1949 as La Bomba Bar in what is now MIDTOWN. Leon Yarborough bought it in 1953 and later renamed it Leon's. Closed in January 2015.

LEOPARD SKIN VEST
SAM HOUSTON wore this on special occasions. It was actually a jaguar skin.

LEWIS, CARL
(1961–present)
Olympic gold medal winner and track and field record holder who attended UNIVERSITY OF HOUSTON.

LEWIS, GUY V.
(1922–present)
Men's basketball coach from 1956 to 1986 at UNIVERSITY OF HOUSTON. In the late 1950s, he helped popularize the dunk shot. In the 1960s, he aggressively recruited African American players. Led the COOGS to the GAME OF THE CENTURY in 1968 and during PHI SLAMA JAMA era in the early 1980s. Elected to the Basketball Hall of Fame in 2013.

LI CUNXIN
(1961–present)
Ballet dancer invited from the Beijing Dance Academy to the Houston Ballet by artistic director BEN STEVENSON. He would later defect in 1981 and write *MAO'S LAST DANCER*.

LIFE FLIGHT
A medical rescue helicopter service, founded at HERMANN HOSPITAL in 1976 by Dr. Red Duke.

LIGHTS IN THE HEIGHTS
An annual, outdoor, block party–style Christmas party in WOODLAND HEIGHTS featuring decorated homes, music and holiday revelry since 1988. Shortened to LITH.

LIGHT SPIKES
Temporary sculpture installation for 1990 WORLD ECONOMIC SUMMIT by architect Jay Baker. Now installed at BUSH INTERCONTINENTAL AIRPORT.

LIL KEKE
(1976–present)
A native-born hip-hop artist and protégé of DJ SCREW.

LINKLATER, RICHARD
(1960–present)
Filmmaker who graduated from Bellaire High School. Wrote and directed award-winning film *BOYHOOD*, partially set and shot in Houston.

LIQUID CITY: HOUSTON WRITERS ON HOUSTON
A collection of short stories by Houston writers about Houston with photos by Paul Hester, commissioned by the Houston International Festival in 1987.

LITH
Abbreviation for LIGHTS IN THE HEIGHTS.

LIVABLE FOREST, THE
PR nickname for KINGWOOD, Texas.

LIVE OAK
A ubiquitous local tree, known for expansive canopy and its hardiness in the face of Houston weather. Its roots have no respect for sidewalks. It gets its name by staying green year-round and quickly dropping its leaves in March.

LOCAL OPTION
The power of a city government to self-regulate on alcoholic beverage sales. See DRY.

LOFT
A work and/or residential space, rare in Houston until the 1990s, when developers created new lofts to emulate old, restored warehouse-style lofts, with features that might include open floor plans, concrete flooring, brick walls and exposed metal HVAC ducts.

LONE STAR
Texas is the Lone Star State.

LONE STAR COLLEGE
A local system of six community colleges founded in 1973, formerly the North Harris County College and then the North Harris Montgomery Community College. It took the formal name Lone Star College System in 2008.

The Loop.

LOOPER/INNER LOOPER
Person who resides inside THE LOOP.

LOOP, THE
Interstate 610, which is the informal boundary for inner Houston.

LOST WARD, THE
The portion of the THIRD WARD cut off geographically and emotionally from the rest of the ward by the Gulf Freeway.

LOVE, JIM
(1927–2005)
Popular visual artist known for oversized, outdoor sculptures with an industrial flavor, see *Love Jack* at the MENIL COLLECTION and *Portable Trojan Bear* in HERMANN PARK.

LOVETT, LYLE
(1957–present)
Native Houstonian and Grammy-winning singer/songwriter from Klein who began his career playing at ANDERSON FAIR. He attended TEXAS A&M with ROBERT EARL KEEN.

LOWER WESTHEIMER
Located where Westheimer Street originates, concluding at South Shepherd. Known for vintage clothing stores, bars and restaurants, tattoo parlors, alternative and gay culture and, most recently, mattress stores.

LUBE JOB
Slang for eating a meal at Luby's Cafeteria.

"LUV YA BLUE"
Fan motto for former football team the HOUSTON OILERS, debuted when COLUMBIA BLUE and white pompoms were handed out at Monday Night Football in 1978. Dovetailed into a booming city's civic pride and led to countless fan-made items, including a song by Mack Hayes.

LYNCHBURG FERRY
A free, HARRIS COUNTY–owned ferry located where the SAN JACINTO RIVER empties into THE SHIP CHANNEL and connecting BAYTOWN to LA PORTE, near the SAN JACINTO Battleground, since 1888.

MacGregor, Henry
(1855–1923)
Philanthropist, politician and owner of an electric streetcar company. Helped extend Houston southward and donated the land that would become MacGregor Park.

MacGregor Park
Southeast Houston park lining Brays Bayou from Almeda to Calhoun and past to OST, bequested by Henry MacGregor.

Magnolia Ballroom
The 1910 Magnolia Brewing Building is the home to this event space in Market Square Historic District. Bart Truxillo restored it, and it became Houston's first Protected Landmark.

Magnolia Brewery
Formerly the Houston Ice & Brewing Company, founded in 1892. Declined rapidly during Prohibition.

Magnolia City
Houston nickname originating in 1870s for the popular flowering tree—less common lately.

Magnolia Park
Predominantly Hispanic community southeast of Houston near Harrisburg, founded in 1909, incorporated in 1913 and annexed by Houston in 1926.

Main Street Theater
Local performing arts venue, founded in 1975. Moved into Rice Village in 1981 and ran a second stage at Chelsea Market from 1996 to 2014.

Majestic Metro, the
Former movie house the Ritz Theatre, designed by William Ward Watkin in 1926 in Market Square, renamed in 1972 and closed in 1984. Reopened as a special events venue in 1990.

MAJORITY-MINORITY
Condition in Houston and Texas where self-identified non-Hispanic whites compose less than 50 percent of the population but are still the largest ethnic group. Thus, the composite minority groups form the majority. Occurred in early 2000s. Also known as minority-majority.

MAMA NINFA
Nickname for MARIA NINFA RODRÍGUEZ LAURENZO.

MANDOLA
Family name of local restaurateurs, including Tony, Damian, Dominic, Frank, Joseph and Luke Mandola.

MANNED SPACECRAFT CENTER
Original name of NASA's JOHNSON SPACE CENTER in CLEAR LAKE. Renamed for President Johnson in 1973. Home to MISSION CONTROL, astronaut training and SPACE CENTER HOUSTON.

MAO'S LAST DANCER
Autobiography of Houston Ballet's LI CUNXIN, later made into a film in 2009.

MARFRELESS
Landmark, speakeasy-style, unmarked bar and infamous make-out spot that opened in 1972. Also known as THE BLUE DOOR for its signature, distinguishing exterior feature. It moved to the River Oaks Shopping Center in 1976 and closed in 2013 due to high rent demands from landlord WEINGARTEN. Reopened a year later with new owners and a swanky and noisy upgrade to the interior.

MARKET SQUARE HISTORIC DISTRICT
HISTORIC DISTRICT at the heart of Downtown. Includes MARKET SQUARE PARK (former public market and location of city hall), the COTTON EXCHANGE BUILDING, LA CARAFE, OKRA CHARITY SALOON and UNIVERSITY OF HOUSTON–DOWNTOWN.

MARKET SQUARE PARK
A city park at the center of MARKET SQUARE HISTORIC DISTRICT since 1986. Donated by August Allen in 1854 for a public market, it was the center of regional COTTON and produce trading in late nineteenth and early twentieth

centuries. The site of multiple city hall buildings from 1841 to 1939. Redesigned and reopened in 2010 with a NIKO NIKO'S restaurant, a dog park and a sculpture by JAMES SURLS.

MARK'S AMERICAN CUISINE
MONTROSE restaurant in a renovated 1920s church, opened in 1997 and named for owner/chef Mark Cox.

MARVEL MCFAY
The gypsy-themed mascot of ASTROWORLD.

MARY'S
Former landmark gay bar near the intersection of Westheimer and Montrose Boulevard. Now the coffee house Blacksmith.

MASTERS
Nickname for college masters, RICE UNIVERSITY's residential college advisors, who live on campus, usually married.

MATCH
The MIDTOWN Arts & Theater Center Houston, a home for multiple arts organizations and showcase for performing and visual arts, on Main and Holman.

MATTRESS MACK
Nickname for JIM MCINGVALE.

"MAYBE IT WILL FLOOD!"
Declaration made by Houston children when it rains too much, hoping for something akin to a snow day.

MCCARTHY, GLENN
(1907–1988)
WILDCATTER turned OILMAN. Built the landmark SHAMROCK HOTEL and hosted "Houston's biggest party" when it opened in 1949. Known as the "King of the Wildcatters" and "Diamond Glenn." Widely considered to be the inspiration for Jett Rink in the novel *Giant*.

MCINGVALE, JIM
(1951–present)
Furniture store owner and philanthropist. Opened GALLERY FURNITURE in 1981. Famous for commercials where he shouts, "SAVE YOU MONEY!" Purchased the Westside Tennis Club in 1995 and upgraded it to attract national events. Nicknamed MATTRESS MACK.

MCKISSACK, JEFF
(1902–1980)
Former mailman who built THE ORANGE SHOW out of his home from found materials as a monument to the fruit.

MCMANSION
Slang for a residence built in an extravagant style, typically more house than a family needs and too large for the exiting site. DEED RESTRICTIONS can (but do not often enough) limit the preponderance of this style of home.

MCMURTRY, LARRY
(1936–present)
Pulitzer Prize–winning author of *Lonesome Dove* who earned an MA at RICE UNIVERSITY in 1960 and then lived in Houston in the 1960s while teaching at Rice. Set the novels *MOVING ON*, *All My Friends Are Going to Be Strangers*, *TERMS OF ENDEARMENT* and *THE EVENING STAR* in Houston. Opened his famous bookstore BOOKED UP in Houston.

M.D. ANDERSON
A leading cancer hospital in the MED CENTER named for MONROE DUNAWAY ANDERSON, who was co-owner of the world's largest cotton trading company.

MECOM FOUNTAIN
A landmark public water feature on the traffic circle where Montrose Boulevard originates, near HERMANN PARK, built in 1964 in the former Sunken Gardens and named for John Mecom. A famous local site for bridal and QUINCEAÑERA portraits, as well as RICE UNIVERSITY student pranks.

MEDICAL CENTER, THE
Formally known as THE TEXAS MEDICAL CENTER. A collection of hospitals, schools, clinics, professional practice offices and hotels south of HERMANN PARK, larger than many other cities' downtowns. Also known as the MED CENTER.

MEFO
Nickname for MARCELLUS FOSTER, founder of the *HOUSTON CHRONICLE*.

MEMORIAL PARK
A public 1,500-acre forest west of Downtown, north of RIVER OAKS. The former site of CAMP LOGAN, a U.S. Army training camp from 1917 to 1923. Donated by the HOGG family, opened in 1924 and named in honor of World War I veterans. The park features a golf course, running path, the Houston Arboretum and the HO CHI MINH TRAIL and is home to BAYOU CITY ARTS FESTIVAL and the RODEO TRAIL RIDERS campsite. In 2011, it suffered a catastrophic loss of trees during a months-long DROUGHT.

MENIL COLLECTION, THE
A private art museum founded by DOMINIQUE DE MENIL. Opened in 1986 in MONTROSE adjacent to the ROTHKO CHAPEL and the UNIVERSITY OF ST. THOMAS. Surrounded by bungalows (many of which were owned by De Menil) in an instant landmark designed by RENZO PIANO, who famously stated that the building is a portrait of DOMINIQUE DE MENIL. The collection of Modernist and indigenous art is known worldwide. The campus includes the Byzantine Chapel, TWOMBLY GALLERY and RICHMOND HALL. Always free to the public. Nicknamed THE MENIL.

MENIL GRAY
Nickname for the color of the bungalows surrounding the MENIL COLLECTION, so as to create a unified campus and not compete with the RENZO PIANO landmark. Possibly suggested by architect HOWARD BARNSTONE. In the 1970s, DOMINIQUE DE MENIL presented an art exhibition titled "Gray Is the Color" at Rice.

MENNINGER CLINIC, THE
A local psychiatric treatment, research and education facility since 1925.

MENU OF MENUS
Annual restaurant showcase with IRON FORK cooking competition, hosted by the *HOUSTON PRESS*, since 2003.

MESSINA, LOUIS
A concert producer and promoter who grew PACE CONCERTS with Allen Becker into a national company, which grew into SFX, then folded into Clear Channel and was finally renamed Live Nation. He founded the Messina

Group in 2001 and soon partnered with AEG Live.

MUSEUM DISTRICT

MetroRail Station.

METRO
Nickname for the Houston Metropolitan Transit Authority, created in 1979.

METRORAIL
The light rail line connecting Downtown to THE MEDICAL CENTER and the ASTRODOME, opened in 2004, with additional lines in 2015.

MET, THE
Nickname for Downtown's Metropolitan Racquet Club, now simply the Downtown Club.

MEXICO
Texas's neighbor to the south, across the RIO GRANDE. Coahuila y Tejas was a former Mexican state established in 1824. It split apart into separate departments. Following their split from SPAIN, Mexico permitted Anglo EMPRESARIO Moses Austin and his son, STEPHEN F. AUSTIN, to colonize Mexican Texas. In 1836, Texas won independence from Mexico, although Mexico had a tough time letting go. The Mexican-American War settled the boundary issue ten years later, after Texas was annexed by the United States.

MEYERLAND
A mostly residential community in southwest Houston, which opened in 1955 and is known for its large Jewish community.

MFAH
The Museum of Fine Arts, Houston. Also known as the MFA. Organized in 1900 and founded in 1913 as the Art League Houston, it is the oldest art museum in Texas. Opened in 1924 at its current location on Bissonnet in the MUSEUM DISTRICT in a neoclassical structure by architect WILLIAM WARD WATKIN, with two subsequent additions by Ludwig Mies van der

Rohe. The campus includes a Sculpture Garden, GLASSELL SCHOOL OF ART and the Audrey Jones Beck Building by architect Rafael Moneo. The MFAH owns house museums BAYOU BEND and RIENZI.

MIDMAIN
Collection of bars, restaurants and stores in the 3400 to 3700 blocks of Main near West Alabama. The Continental Club was the first to stake a claim to this transitional neighborhood on the southern edge of MIDTOWN.

"MIDNIGHT SPECIAL"
A folk song popularized by Lead Belly in the early twentieth century, which includes the lyrics: "If you're ever in Houston, well, you better do the right/ You better not gamble, there, you better not fight."

MIDSTREAM
The division of the OIL AND GAS industry dedicated to the transportation, storage and wholesale selling of CRUDE OIL or NATURAL GAS.

MIDTOWN
A mixed-use neighborhood south of Downtown and north of MUSEUM DISTRICT, still struggling to establish an identity but known mostly for bars, restaurants and multi-unit apartment buildings.

MIDTOWN ARTS DISTRICT
Midtown Management District created this Midtown group in 2012 for improved branding and fundraising, as well as to highlight the artsy and offbeat institutions there.

MID-TROSE
The area where MIDTOWN rubs up against the eastern edge of MONTROSE and the Downtown street grid reorients to an east–west grid. Coined by MIDTOWN bar Wooster's Garden in 2014.

MILLER OUTDOOR THEATER
Outdoor, covered performing arts venue in HERMANN PARK, perched on THE HILL, since 1968.

MILLIONAIRE BACHELOR

Houston has benefitted financially from several unmarried philanthropists, such as M.D. ANDERSON, Robert Welch, BEN TAUB, GEORGE HERMANN and WILLIAM MARSH RICE (divorced, no children).

"MIND PLAYING TRICKS ON ME"

The signature song by local hip-hop group GETO BOYS, released in 1991. *Rolling Stone* magazine ranked it as the fifth-greatest hip-hop song ever in 2012.

MINIMUM LOT SIZE AREA

A City of Houston designation that controls non-deed-restricted residential properties. Until the late 1990s, it restricted townhouses to two per five-thousand-square-foot lots, forcing growth outward and hastening SPRAWL. Now it allows lots to be subdivided for increased townhome development. A tool for the city without ZONING to control development.

MINUTE MAID PARK

Home to the Houston ASTROS, formerly the Ballpark at Union Station, formerly Enron Field. Also known as "THE JUICE BOX." Home to Jeff Bagwell and CRAIG BIGGIO statues.

MISSION CONTROL

Nickname for NASA's MANNED SPACECRAFT CENTER, later JOHNSON SPACE CENTER in CLEAR LAKE, where all space missions were monitored and controlled. Whenever an ASTRONAUT says, "Houston…," they are addressing Mission Control.

MISSOURI CITY

A nineteenth-century railroad town southwest of Houston. Hoping to lure residents from St. Louis, the original real estate developers named it after that state. Now it is mostly a bedroom community for Houston commuters.

MISS 3RD WARD

Alter ego pageant character from BEYONCÉ KNOWLES's song and video "Pretty Hurts."

MITCHELL CENTER FOR THE ARTS

Formally the Cynthia Woods Mitchell Center for the Arts. Endowed by the Mitchell family in honor of CYNTHIA WOODS MITCHELL in 2003 at UNIVERSITY

OF HOUSTON to promote performing, visual and literary arts collaborations through community engagement and alliances with the School of Art, the Moores School of Music, the School of Theatre and Dance, the Creative Writing Program and the BLAFFER ART MUSEUM.

MITCHELL, CYNTHIA WOODS
(1922–2009)
Philanthropist, supporter of the arts, wife of GEORGE MITCHELL. She attended UNIVERSITY OF HOUSTON, where her family endowed the CYNTHIA WOODS MITCHELL CENTER FOR THE ARTS. She and her husband lived in Galveston and led preservation efforts there. The Woodlands' performing arts venue, the CYNTHIA WOODS MITCHELL PAVILION, is named in her honor.

MITCHELL ENERGY
Company founded by GEORGE MITCHELL and purchased by Devon Energy in 2002 for $3.5 billion.

MITCHELL, GEORGE P.
(1919–2013)
Native Galvestonian, OILMAN and philanthropist. Developer of THE WOODLANDS, husband to CYNTHIA WOODS MITCHELL. He built Mitchell Energy and Development Corporation into a Fortune 500 company through his work in OIL AND GAS. He became a leading innovator in FRACKING. Led the restoration of historic GALVESTON's the Strand.

MOB, THE
Marching Owl Band at RICE UNIVERSITY. Satirical ensemble that performs during sporting events and popularized "Louie, Louie" for all subsequent marching bands.

MOELLER'S BAKERY
A neighborhood bakery since 1930, currently in BELLAIRE.

MOJO HAND: THE LIFE & MUSIC OF LIGHTNIN' HOPKINS
Biography of local blues legend LIGHTNIN' HOPKINS, by Tim O'Brien and David Ensminger, published in 2013.

MONTROSE
A general geographic name that includes collection of neighborhoods roughly west of Downtown, east of River Oaks, south of Allen Parkway and north of US 59. Nicknamed THE TROSE or the Montrose.

MONTROSE ADDITION, THE
The formal name for the city's first large-scale subdivision, platted in 1911 by John Link and the Houston Land Corporation and named for the Scottish town. The residential development of large and small homes was laid out around Montrose Boulevard at Alabama and includes AUDUBON PLACE and FIRST MONTROSE COMMONS. Nicknamed "THE TROSE" or "the Montrose."

MONTROSE GAZE
Houston's first gay community center, founded in 1972.

MONTROSE ROLLERBLADE DANCER
A hairdresser who free-form dances on rollerblades at the intersection of Montrose Boulevard and Allen Parkway for the entertainment of commuters. Appeared on TV's *America's Got Talent* in 2014. Stage name for Juan Carlos Restrepo, also known as JUAN CARLOS.

Montrose Rollerblade Dancer.

MONTROSE'S LIVING ROOM
Self-given nickname for the bar Rudyard's.

MOODY, BETTY
(1944–present)
Gallerist, owner of Moody Gallery since 1975.

MOODY PARK
A city park in the near north side since the 1920s and home to LUIS JIMENEZ's *Vaquero* sculpture.

MORGAN, COMMODORE CHARLES
(1795–1878)
Industrialist who owned a steamship company and built a local railroad to ship goods to and from New Orleans. He was an early promoter of THE SHIP CHANNEL and instrumental in its development by 1876. Called "the Father of the Houston Ship Channel."

MORGAN'S POINT
A major bend in THE SHIP CHANNEL, named for James Morgan, who bought the strip of land from SAN JACINTO RIVER to GALVESTON BAY in 1834. Formerly known as New Washington and incorporated in 1949.

MOTHER OF HOUSTON, THE
Nickname of CHARLOTTE ALLEN, wife of Houston co-founder AUGUSTUS ALLEN.

MOTHER WARD, THE
Nickname for the FOURTH WARD.

MOUNT RUSH HOUR
Collection of four of DAVID ADICKES'S PRESIDENTS HEADS along I-45 North, south of I-10.

MOVING ON
A sprawling, Houston-set novel by LARRY MCMURTRY, published in 1970 and featuring Houston sites RICE UNIVERSITY and SOUTHAMPTON.

MOVING SIDEWALKS, THE
Psychedelic blues-rock band founded by BILLY GIBBONS in 1966; reunited in 2013.

MR. HOUSTON
Nickname for JESSE H. JONES.

MT. HOUSTON
A street in Northeast Houston; however, Houston is FLAT.

MUDBUG
Slang for crawfish.

MULLENWEG, MATT
(1984–present)
Native Houstonian, code-writer and founder of Automattic and WordPress, the worldwide open-source software. He attended HSPVA and the UNIVERSITY OF HOUSTON but dropped out in 2004.

MULLET, THE
Formally the Kingspoint Mullet. Houston's largest graffiti destination and unrestricted art space, established in 2011 by the Southern Artists Foundation.

MURDER IN TEXAS
A 1981 TV movie telling the story of the murder of RIVER OAKS socialite Joan Robinson Hill.

MUSEUM DISTRICT
An informal collection of neighborhoods between the MEDICAL CENTER and MIDTOWN. Includes nineteen museums within walking distance.

MUTT CITY
Nickname given to Houston by *Oxford American Magazine*'s 2012 article "Savoring Mutt City," in which it claims that Houston is "the most ethnically diverse municipality in the U.S."

MUTTON BUSTIN'
A RODEO event where heavily padded children ride or race sheep, in the style of adults riding bulls or broncos. Looks dangerous.

MY TABLE
Local bimonthly food, restaurant and dining magazine founded by Teresa Byrne-Dodge in 1994. Hosts Houston's annual culinary awards.

NANOTECHNOLOGY
The manipulation of atoms and molecules, employed famously in the fields of semiconduction and microfabrication. RICE UNIVERSITY's Nobel laureate Rick Smalley was a champion of nanotechnology and is credited for co-creating BUCKYBALLS.

NAPOLEON OF THE WEST
Self-given nickname of SANTA ANNA, who met his Waterloo at the BATTLE OF SAN JACINTO.

NASA
National Aeronautics and Space Administration, a government agency that established the MANNED SPACECRAFT CENTER in CLEAR LAKE in 1961. It was renamed the JOHNSON SPACE CENTER in 1973. From the Apollo era to the end of the space shuttle era, NASA was a major employer in Houston.

NASH, JOHNNY
(1940–present)
Native Houstonian and singer/songwriter known for the number one song "I Can See Clearly Now."

NATURAL GAS
A hydrocarbon energy source made mostly of methane. Also known as GAS.

NAVIGATION
A major street in the East End.

NEARTOWN
Generally, the name for the collection of neighborhoods southwest of Downtown and north of RICE UNIVERSITY. Also identified as MONTROSE. Formally, the Neartown Association acts as the official collection of smaller civic associations, founded in 1963, including AUDUBON PLACE, AVONDALE, Castle Court, CHERRYHURST, Dearborn, East Montrose, FIRST MONTROSE COMMONS, Hyde Park, Lancaster Place, Mandell Place, Museum District Business Alliance, North Montrose, Park, Richwood Place, Roseland Estates, Vermont Commons, Westheimer Alabama Montrose Mulberry, WESTMORELAND and Winlow Place.

NEIGHBORHOOD CENTERS
In 1907, Alice Graham Baker founded the Houston Settlement Association, which extended educational, industrial and social aid to those in need. Now a network of fifty-nine service sites bringing resources and education to developing communities.

NELSON, WILLIE
(1933–present)
Iconic country singer/songwriter. Wrote "Crazy," "Funny How Time Slips Away" and "Night Life" while working as a DJ in PASADENA in the late 1950s.

NERD PLANET
Nickname for Third Planet Sci-Fi Superstore, a comic book, science fiction and fantasy collectibles and gaming store since 1975.

NEWBURY, MICKEY
(1940–2002)
Native Houstonian, country singer and songwriter. He rejected the conventions of Nashville and became associated with the "Outlaw County" movement. He wrote the psychedelic song "Just Dropped In (To See What Condition My Condition Was In)" for KENNY ROGERS'S band the First Edition. Name-checked in Waylon Jennings's "Luckenbach, Texas."

NEWSTONIAN
A new Houstonian. Houston is known for its constant supply of them.

NEW YORK BAGEL AND DELI
A southwest Houston landmark since the 1970s; also known as New York Coffee Shop.

NICKEL, THE
Nickname for the FIFTH WARD.

NIELS ESPERSON BUILDING
Iconic Downtown high-rise built by Mellie Esperson in honor of her late husband in 1927. Famous for its Italian

Niels Esperson Building.

Renaissance details and orange-lit limestone *tempietto* on top. It was once the tallest building in Houston.

NIKO NIKO'S
Landmark family-owned Greek restaurant in MONTROSE since 1977, with locations in MARKET SQUARE PARK and PEARLAND.

NINFARITA
Trademarked margarita from famed TEX-MEX restaurant NINFA'S since 1973.

NINFA'S
Landmark TEX-MEX restaurant founded by MAMA NINFA in her tortilla factory on Navigation Boulevard in the EAST END in 1973.

NIXON IN CHINA
Opera by John Adams that made its debut at HGO in 1987.

NORHILL
Residential neighborhood north of West Eleventh and east of Studewood. Developed in the 1920s by WILL HOGG for blue-collar families. HISTORIC DISTRICT since 2000.

NORTEÑO
A genre of traditional northern Mexican music known for the accordion and *bajo sexto* guitar, lending a big influence on TEJANO music.

NORTH FREEWAY
Interstate 45 north of Downtown.

NORTH/SOUTH BOULEVARD
Two signature, if somewhat interchangeable, residential streets in BROADACRES and BOULEVARD OAKS, known for their mansions, mature LIVE OAK canopies and ESPLANADES.

"NO, SIR, MR. PRESIDENT. ARE YOU?"
Reporter DAN RATHER's response to President Nixon's "Are you running for something?" after getting applause at a press conference in JONES HALL on March 19, 1974.

NOTARO, TIG
(1971–present)
Stand-up comedian who attended Cypress Creek High School, known for bluntly addressing her cancer diagnosis in her act.

NOTSUOH
Houston spelled backward; a former, early twentieth-century citywide party in the spirit of Mardi Gras; a current, late twentieth-century Downtown bar/gallery.

Notsuoh.

NRG
A local energy company that acquired Reliant Energy in 2009 and added its name to all the buildings in the former ASTRODOMAIN in 2014. Sometimes pronounced "Nerg."

NUDU
The beanie-style African cap worn by ZZ TOP's BILLY GIBBONS.

NUMBERS
Also knows as #'s, a landmark MONTROSE nightclub and live music venue, opened in 1978 and attracting a mostly Goth and punk crowd. Subject of the documentary film FRIDAY I'M IN LOVE.

NUTCRACKER MARKET
A holiday shopping event hosted by the Houston Ballet in conjunction with its Christmas production.

OAKIE
Slang for a resident of Garden Oaks or Oak Forest.

O&G
Abbreviation for OIL AND GAS.

"OASIS OF LOVE, THE"
The former motto for Lakewood Baptist Church. Also, a popular bumper sticker in the 1980s.

OCEAN OF SOUL, THE
The marching band of TEXAS SOUTHERN UNIVERSITY. Also known as the Ocean, the band was founded in 1969.

OFFSHORE DRILLING
Technique for extracting CRUDE OIL from underwater seabeds. HUMBLE OIL & REFINING COMPANY built the first in Texas in 1916 near BAYTOWN.

O. HENRY
(1862–1910)
Pen name of William Sydney Porter, American writer who moved to Houston in 1895 to work as a columnist for the *HOUSTON POST* but left quickly when accused of embezzlement from previous work in Austin.

OIL
Shortened version of CRUDE OIL, discovered locally in BEAUMONT at SPINDLETOP in 1901.

OIL AND GAS
General name for the business of finding, extracting, transporting and selling CRUDE OIL/petroleum and NATURAL GAS from geological sources. The industry is composed of three divisions: UPSTREAM, MIDSTREAM and DOWNSTREAM.

OIL BOOM
The local, sudden economic growth following the discovery of CRUDE OIL at SPINDLETOP in 1901 that helped grow Houston into the major city it is today. Houston has "booms" every few years, the latest from innovations in

FRACKING technology. Successive booms have transformed Houston quickly. Also known as BOOM.

OIL BUST
The 1980s recession caused by reduced demand and OPEC's lowering of CRUDE OIL prices, reaching related fields in finance and real estate. Houstonians live in fear of future busts but are confident economic diversity will protect them. Also known as BUST.

OILERS, THE
Houston's National Football League team. Began as charter members of the American Football League, in which it won two championships. Founded in 1960 by BUD ADAMS. Had a home in the ASTRODOME from 1967 to 1998, when the team moved to Tennessee and was renamed the Titans. The source of great civic pride during the LUV YA BLUE years in the late 1970s and early 1980s, when they were led to the playoffs by BUM PHILLIPS and EARL CAMPBELL.

OILMAN
A term for any person working in the oil business, including engineers, investors, speculators and WILDCATTERS.

OIL RIG
A structure for oil well drilling.

OKRA
Organized Kollaboration on Restaurant Affairs. Founded in 2011 as a loose affiliation of like-minded bar and restaurant owners to promote and advocate for charitable causes and lobby local government for improved industry standards and sympathetic civic ordinances.

OKRA CHARITY SALOON, THE
A bar in the MARKET SQUARE HISTORIC DISTRICT. As an extension of OKRA's core beliefs, it donates 100 percent of its proceeds monthly to a charity voted on by the customers. Opened in 2012.

OLAJUWON, HAKEEM
(1963–present)
Nigerian-born former UNIVERSITY OF HOUSTON basketball player and member of PHI SLAMA JAMA. Led the HOUSTON ROCKETS to two

championships and played most of his career here. He won Olympic gold in 1996 and is a member of the Basketball Hall of Fame. Developed the move THE DREAM SHAKE. With Houston Rocket Ralph Sampson, he was half of the powerhouse duo the TWIN TOWERS. In 2012, he founded the apparel and lifestyle product line by DR34M, with headquarters in the restored West Mansion in CLEAR LAKE. His number, 34, is retired by the HOUSTON ROCKETS. Nicknamed THE DREAM. Formerly known as AKEEM.

OLD CAPITOL CLUB
The center of Houston politics in the 1950s, in THE RICE HOTEL, site of the first capitol of the REPUBLIC OF TEXAS.

OLD CHIEF
Sarcastic nickname for SAM HOUSTON, who lived among the CHEROKEES twice in his lifetime.

OLD QUARTER ACOUSTIC CAFÉ
Former Downtown landmark bar where singer/songwriters played. TOWNES VAN ZANDT recorded a live album in 1973. Now located in GALVESTON.

OLD SAM JACINTO
Nickname for SAM HOUSTON, the hero of the BATTLE OF SAN JACINTO.

OLD SIXTH WARD
Residential neighborhood north of ALLEN PARKWAY and west of Downtown in the former SIXTH WARD. Known for its high concentration of Victorian homes. HISTORIC DISTRICT since 1998. Since 2007, all homes are protected from DEMOLITION or alteration. Houston's only Protected Historic District. Listed on the National Register of Historic Places.

OLD THREE HUNDRED, THE
The settlers who followed STEPHEN F. AUSTIN and had received land grants to colonize Mexican Texas by the mid-1820s. Mostly planters, the colonists settled from the Brazos, Colorado and San Bernard Rivers out to the GULF OF MEXICO.

ONE SHELL PLAZA
Home to Shell Oil. Houston's tallest building from 1971 to 1980. GERALD HINES's first Downtown high-rise.

O'QUINN, JOHN
(1941–2009)
Local trial/plaintiff's lawyer. Grew up in WEST U AND went to Lamar High School and UNIVERSITY OF HOUSTON Law Center. The John M. O'Quinn Foundation has endowed many projects in Houston, and O'Quinn's name is on countless buildings and sites around town.

ORANGE POPSICLE
Nickname for the Houston ASTROS baseball uniform with horizontal, mid-torso orange stripes, lasting from 1975 to 1986.

ORANGE SHOW, THE
Formally the Orange Show Center for Visionary Art. A folk art installation built by a retired mailman, opened in 1979. The Orange Show Foundation took over in 1982. Now a nonprofit organization promoting arts education, folk art, THE BEER CAN HOUSE and THE ART CAR PARADE.

ORBIT
The fuzzy, green-headed mascot of the ASTROS.

OST
Shortened version of the street Old Spanish Trail.

OSTEEN, JOEL
(1963–present)
Self-taught pastor of LAKEWOOD CHURCH, TV evangelist and best-selling author. Famous for his positive message and prosperity theology.

OTC
The annual Offshore Technology Conference held at NRG Center attracts more than eighty thousand attendees and is the world's largest energy-related trade show, founded in 1969. Also, a not-so-secret boost in business for bars, restaurants and strip clubs.

OTL
Shortened version of OUTSIDE THE LOOP.

OUTSIDE/INSIDE THE LOOP
Terms for Interstate 610, used in mostly meaningless discussions of social inclusivity and real estate prices.

O-Week
Nickname for Orientation Week at Rice University.

Owls, the
Name for the athletic teams of Rice University; their mascot is Sammy the Owl.

PACE CONCERTS
A concert promotion company founded by Allen Becker and Sidney Shlenker in 1966, when JUDGE HOFHEINZ needed non-sports attractions to fill the ASTRODOME. LOUIS MESSINA moved Pace from promoting motor sports and trade shows to live music and then sold to SFX and later Clear Channel, from which it spun off into Live Nation.

PANCHO CLAUS
Red zoot-suited alter ego of Richard Reyes, who has distributed Christmas presents to low-income Hispanic neighborhoods from a parade of souped-up low-riders since the 1980s.

PAPERCITY
A free monthly magazine featuring Houston art, culture, fashion, home décor and lifestyle themes, as well as society event photographs. Founded in 1994.

PAPPAS
A prolific restaurant family since the 1976, known for the Strawberry Patch, Pappas Brothers, Pappadeaux Seafood Kitchen, Pappasito's Cantina, Pappas Bar-B-Q and, finally, the Greek-themed Yia Yia Mary's.

PARIS, TEXAS
A sprawling Wim Wenders road movie from 1984, with scenes set and filmed in Houston.

PARSONS, JIM
(1973–present)
Native Houstonian and Emmy-winning actor who attended Klein Oak High School and the UNIVERSITY OF HOUSTON. A founding member of Infernal Bridegroom Productions.

PARTY ON THE PLAZA
A former Thursday happy hour concert series in JONES PLAZA from the 1990s. Since moved to DISCOVERY GREEN.

PASADENA
A neighboring boomtown known famously for its blue-collar rednecks who work in the nearby petrochemical refineries. Hometown to closed honky-tonk GILLEY'S CLUB.

PASA-GET DOWN-DENA
Nickname for PASADENA, Texas, reflecting its honky-tonk, blue-collar roots; coined by 97Rock's DJ Moby.

PEACOCK RECORDS
Blues, R&B and gospel record label founded by Don Robey in Houston in 1949. Known for acts such as Big Mama Thornton, Little Richard, Clarence Gatemouth Brown and Memphis Slim. Robey merged his label with Duke Records to become Duke/Peacock.

PEARLAND
A "healthier" suburb to nearby SUGAR LAND.

PECAN PIE
A popular local dessert with native nuts (technically, they're drupes). GOODE COMPANY ships them nationwide.

PECAN TREE
A popular, hardy local tree known for its edible fruit and popularized by Governor Big Jim Hogg. The state tree of Texas. The trees provide great shade, but the pecan shells are tough on children's bare feet.

PEGGY PARK
City park in the THIRD WARD, dedicated to Peggy MacGregor, who provided the city with the land connecting HERMANN PARK to MACGREGOR PARK along BRAYS BAYOU.

PEGSTAR CONCERTS
A local concert promoter founded by Jagi Katial in the early 2000s. Pegstar teamed up with Omar Afra and reopened FITZGERALD'S in 2010.

PENGUIN ARMS
An UPPER KIRBY apartment building from 1950 in the Googie style of architecture.

PENNZOIL

Oil company founded in 1953 by brothers Hugh and William Liedtke with GEORGE H.W. BUSH as ZAPATA PETROLEUM COMPANY. Merged with South Penn Oil Company in the early 1960s.

PENNZOIL PLACE

A dramatic, signature, landmark Downtown high-rise designed by architect PHILIP JOHNSON and John Burgee and built by GERALD HINES in 1976.

PETROCHEMICAL

Products derived from PETROLEUM. Houston is home to many major petrochemical companies due to its proximity to the refineries in BAYTOWN.

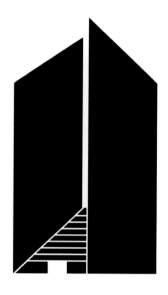

Pennzoil Place.

PETROLEUM

Includes both natural, unprocessed CRUDE OILs and products that are made from refined crude oil.

PETROLEUM CLUB, THE

A members-only club in Downtown, operating since 1946. First housed atop the RICE HOTEL, it moved to its current location in the ExxonMobil Building in 1963.

PHILLIPS, BUM
(1923–2013)
Colorful, beloved head coach of the HOUSTON OILERS from 1975 to 1980. Led Houston to two consecutive AFC Championship games, only to lose both times to the PITTSBURGH STEELERS.

PHI SLAMA JAMA

Fake basketball fraternity of the UNIVERSITY OF HOUSTON COUGARS from 1982 to 1983. Included HAKEEM OLAJUWON, CLYDE DREXLER, Michael Young and Larry Micheaux. Also known as "Texas's Tallest Fraternity."

PHỞ
Popular Vietnamese noodle soup, usually with chicken or beef. Hipsters and foodies love to tell you it's pronounced "fuh."

PIANO, RENZO
(1937–present)
Italian architect hired by DOMINIQUE DE MENIL to design her landmark MENIL COLLECTION and the CY TWOMBLY GALLERY.

PICKETT, CECIL
(1923–1997)
University of Houston acting professor and director from 1970 to 1988. He also taught at Bellaire High School and HOUSTON BAPTIST UNIVERSITY and inspired many local students to become professional actors, including RANDY QUAID, DENNIS QUAID, BRENT SPINER, Brett Cullen, Trey Wilson and daughter Cindy Pickett.

PICO DE GALLO
A popular Mexican condiment with tomatoes, onions and chilies—a staple of TEX-MEX restaurants.

PIE BOOTH, THE
Drive-up tent at GOODE COMPANY to accommodate the high traffic during holidays.

PIERCE ELEVATED, THE
The elevated portion of Interstate 45 running above Pierce Street in Downtown. Considered the southern border of Downtown Houston.

PIMP C
(1973–2007)
Stage name for Chad Butler, hip-hop artist who gained fame with BUN B in the UNDERGROUND KINGZ.

PINK PUSSYCAT, THE
A former Richmond Avenue strip club famous for its one-armed stripper.

PITTSBURGH STEELERS
No true Houstonian can ever root for this football team if they remember the HOUSTON OILERS' painful losses to them in 1978 and 1979.

PLAGUE
Term for a flock of GRACKLES.

PLAN II
The honors program at UNIVERSITY OF TEXAS.

POPE, MONICA
(1963–present)
Among Houston's first celebrity chefs. An early advocate for local farmers, ranchers and food producers through her "Eat Where Your Food Lives" program.

PORT OF HOUSTON, THE
Informal name of Port of Houston Authority, the governing body of THE SHIP CHANNEL, guided by the Port Commission and composed of public terminals owned or managed by the port and private companies shipping there.

PPGC
Planned Parenthood Gulf Coast.

PRESERVATION HOUSTON
Local nonprofit committed to promoting preservation and appreciation of Houston's architectural and cultural resources through polite advocacy and education. Founded in 1978 as the Greater Houston Preservation Alliance. Hosts of the GOOD BRICK AWARDS.

PRESIDENTS HEADS
Sculptor DAVID ADICKES's series of U.S. president sculptures.

PREVENTION PARK
The GULF FREEWAY main campus for Planned Parenthood Gulf Coast, opened in 2010.

PRISON SHOW, THE
A call-in radio show on KPFT, addressing issues of all those who are incarcerated, hosted by activist Ray Hill from 1980 to 2011.

PROJECT ROW HOUSE
A nonprofit arts and cultural organization based in abandoned shotgun-style house on Holman Street in the THIRD WARD. Dedicated to community involvement though art, art exhibition, music and literacy. Founded in 1993 by Rick Lowe, who won a MacArthur "Genius Grant" in 2014.

PROTECTED LANDMARK
Permanent designation by the City of Houston by the owner's request, where a structure may only be altered externally, moved or demolished with the permission of the city. The designation transfers to subsequent owners. Not to be confused with LANDMARK.

"PUH-*CON*"
Local pronunciation of *pecan*.

PUMP
Slang for giving a person a ride on a bicycle.

PUMPKIN PARK
Nickname for River Oaks Park, named for the Cinderella pumpkin coach.

PUNCH, THE
Los Angeles Laker Kermit Washington hit HOUSTON ROCKET RUDY TOMJANOVICH in a fight that broke out during a basketball game in 1977, leaving him with a fractured face, unconscious and nearly dead. Also the title of John Feinstein's book in 2002 detailing the fight.

PURPLE DRANK
Nickname for LEAN, a popular underground hip-hop drink that includes prescription-strength cough syrup, soda and candy, popularized by DJ SCREW in the 1990s. Also known as SIZZURP.

PVA
Nickname for HSPVA.

Q
Shortened version of BBQ or BARBECUE.

QUAID
Actor brothers Randy and Dennis, both of whom attended Bellaire High School and UNIVERSITY OF HOUSTON.

QUEEN B
Nickname for BEYONCÉ.

QUESADILLA
A Mexican dish with cheese melted between two tortillas. Also known as "Mexican Grilled Cheese."

QUESO
Shortened version of *chile con queso*. Melted cheese with *chile* peppers served in TEX-MEX restaurants as a dipping sauce.

QUINCEAÑERA
Celebration of a girl's fifteenth birthday in Latin American communities, with many of the same traditions of a sweet sixteen party or a debutante ball.

RAP-A-LOT RECORDS
Hip-hop record label founded by James Prince in 1986, known for producing the GETO BOYS.

RASHĀD, PHYLICIA
(1948–present)
Television and stage actor and Tony Award winner, known for the role of Clair Huxtable on *The Cosby Show*; born and raised in Houston, sister of DEBBIE ALLEN.

RATHER, DAN
(1931–present)
Journalist and former network news anchor. Born in Wharton, he attended Reagan High School in the HEIGHTS. Former news director at KHOU. First TV reporter to cover the assassination of JFK. Famously mocked President Nixon to his face in JONES HALL.

RAVEN, THE
Name given to SAM HOUSTON when he lived among the CHEROKEES. See also COLONNEH.

RDA
Rice Design Alliance.

RDG
Post Oak Boulevard restaurant of Mimi and Robert Del Grande.

REALITY BITES
A 1994 Generation X romantic comedy set and filmed in Houston.

RED NATION
The marketing campaign of the HOUSTON ROCKETS since 2009.

REFINERY
A factory that converts raw materials into useable or marketable products. Baytown is home to many.

R.E.M.
Alternative rock band from Athens, Georgia, that wrote songs "LIGHTNIN' HOPKINS" and "Houston."

"REMEMBER THE ALAMO! REMEMBER GOLIAD!"
The rallying cry by General SAM HOUSTON and the TEXIAN Army at the BATTLE OF SAN JACINTO on April 21, 1836.

RENDEZ-VOUS HOUSTON
Performance for the Texas SESQUICENTENNIAL by Jean Michel Jarre in 1986 that included lasers, music and projections against the west side of Downtown skyscrapers.

REN FEST
Nickname for Texas Renaissance Festival in nearby Plantersville, Texas, since 1974.

REPUBLIC OF TEXAS, THE
A sovereign nation of American and European colonists and Mexican rebels that won its independence from Mexico in 1836. Following the TEXIAN victory at the BATTLE OF SAN JACINTO, Mexican president SANTA ANNA signed the TREATY OF VELASCO. Sam Houston was elected the first president, and the new town of Houston was chosen as the capital. U.S. annexation was accepted in 1845, and the Republic's last day was February 19, 1846. An endless source of pride for all Texans.

RESIDENTIAL BUFFERING ORDINANCE
In a city without ZONING, this is an attempt to ease the pain single-family residences feel when a high-rise is built next door, usually through street and side setbacks, landscape buffers, fences and performance standards. It became popular following the ASHBY HIGH-RISE incident. It was passed by the city council in 2011 but limited to buildings taller than seventy-five feet.

RICE DESIGN ALLIANCE
A nonprofit group founded at Rice University in 1972, dedicated to enhancing the quality of life in Houston through the advancement of architecture and design. RDA publishes the quarterly magazine *Cite: The Architecture & Design Review of Houston* since 1982 and hosts lectures, home tours and design charrettes. Also known as RDA.

RICE EPICUREAN MARKET
The upscale concept by Rice Food Markets, launched in 1988. Rice was founded on Rice Boulevard in the RICE VILLAGE in 1937 by the Levy family.

RICE HOTEL, THE
Former Downtown hotel on the former site of the REPUBLIC OF TEXAS capitol. Built by JESSE JONES in 1913 and closed in 1977. Developer Randall Davis converted it to the Rice Lofts in 1998.

RICE INSTITUTE
School of higher learning that opened in 1912 thanks to the trust of WILLIAM MARSH RICE. Renamed the less nerdy-sounding RICE UNIVERSITY in 1960.

RICE MEDIA CENTER, THE
A temporary-looking building at RICE UNIVERSITY, built in 1970 to house the DE MENIL art collection. Later the home of Rice's movie theater and photography labs until 2014. One of Houston's first metal buildings.

RICE MILITARY
A neighborhood east of MEMORIAL PARK, named for its adjacency to CAMP LOGAN. Since the 1990s, jumbo townhouses have quickly replaced small bungalows due to the easy access to Downtown and the lack of DEED RESTRICTIONS. Informally used for all adjacent neighborhoods.

RICE STADIUM
Houston's first large-scale football stadium, built in 1950. Besides Rice Owls football, it was home to the HOUSTON OILERS before the ASTRODOME, hosted UNIVERSITY OF HOUSTON football from 1951 to 1965 and welcomed rock concerts, many college bowl games, the Super Bowl in 1974 and President Kennedy's "WE CHOOSE TO GO TO THE MOON" speech in 1962.

RICE UNIVERSITY
School of higher learning that opened in 1912 thanks to the trust of WILLIAM MARSH RICE. Named RICE INSTITUTE until 1960.

RICE VILLAGE
Commercial retail neighborhood west of RICE UNIVERSITY developed in the 1940s. Various landlords include RICE UNIVERSITY, WEINGARTEN and

Olson Brothers. Known for its small boutique stores mixed in with less-posh retailers and many bars and restaurants. Also known simply as THE VILLAGE.

RICE, WILLIAM MARSH
(1816–1900)
Houston industrialist and founder of RICE UNIVERSITY. He was murdered by his butler, but attorney CAPTAIN JAMES BAKER was able to save his trust and fulfill the William Marsh Rice Institute for the Advancement of Literature, Art and Science.

RICHARD, J.R.
(1950–present)
A former ace ASTROS pitcher, from 1971 to 1980, when he suffered a stroke. He was homeless in Houston in the 1990s before finding help with a local church. His jersey number was 50.

RICHMOND HALL
A former grocery store on Richmond Avenue, now a satellite building on the MENIL Campus, and permanent installation by artist Dan Flavin.

RICHMOND RAIL
Nickname for the proposed METRORAIL UNIVERSITY LINE, which would connect UNIVERSITY OF HOUSTON, TEXAS SOUTHERN UNIVERSITY, Main Street, MONTROSE, the UNIVERSITY OF ST. THOMAS, the MENIL Campus, NEARTOWN and GREENWAY PLAZA to the GALLERIA and the Hillcroft Transit Center.

RICHMOND STRIP
Retail shops, restaurants and bars on Richmond Avenue past Chimney Rock. Famously noisy on the weekends.

RIDE HERD
A phrase for a COWBOY attending to cattle; supervising someone.

RIENZI
Formally Rienzi Center for European Decorative Arts. The former RIVER OAKS residence of the Masterson family was designed by architect JOHN STAUB, now owned by MUSEUM OF FINE ARTS, HOUSTON, and opened to the public as a house museum in 1999.

RIO GRANDE
The river that serves as the border between Texas and Mexico. Also known as Río Bravo del Norte or Río Bravo.

RIVER OAKS
A wealthy residential neighborhood west of Shepherd Drive and south of BUFFALO BAYOU, founded in the 1920s by Mike and WILL HOGG and Hugh Potter. WILLIAM CLAYTON built the first home there in 1924. Used as a synonym for Houston wealth and power.

RIVER OAKS GARDEN CLUB
An educational and gardening advocacy group founded in 1927. It publishes the *GARDEN BOOK FOR HOUSTON AND THE TEXAS GULF COAST* and hosts the annual AZALEA TRAIL. Its Forum of Civics building at Westheimer and Kirby is a popular wedding venue.

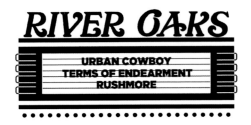

River Oaks Theater.

RIVER OAKS THEATER
A beloved Art Deco movie theater in the River Oaks Shopping Center on West Gray. It opened in 1939 and since 1976 has specialized in independent and foreign films. Converted from a single-screen theater to three when the balcony was closed off. Owner WEINGARTEN REALTY refuses to pledge to protect or preserve this landmark.

RIVERSIDE TERRACE
A residential neighborhood along BRAYS BAYOU and MACGREGOR PARK founded in the 1930s by well-to-do Jewish families who were restricted from buying in RIVER OAKS. Due to lapsed deed restrictions, non-residential structures moved in. Following the departure of many white families, the African American community in adjacent THIRD WARD blended into Riverside Terrace. The documentary film *THIS IS OUR HOME, IT IS NOT FOR SALE* details this transition up to 1987.

ROAD WOMEN
River Oaks Area Democrat women's political action organization.

ROBERTS, LEON
(1951–present)
Former ASTRO outfielder who also played football for the OILERS as an end and a punter.

ROBERTSON STADIUM
Former football, track and soccer stadium on UNIVERSITY OF HOUSTON campus. HISD built the Public School Stadium in 1942 when UH was a part of its community college system. Renamed Jeppesen Stadium and, later, Robertson Stadium. The HOUSTON OILERS played there from 1960 to 1964, and the HOUSTON DYNAMO played there from 2006 to 2011. Demolished in 2012. Replaced by TDECU STADIUM in 2014.

ROBOCOP 2
A 1990 science fiction movie sequel set in futuristic Detroit but filmed in Houston.

ROCC
River Oaks Country Club.

ROCKETS, THE
Houston's NBA team since 1971, with homes in HOFHEINZ PAVILION, THE SUMMIT, COMPAQ CENTER and TOYOTA CENTER. They won back-to-back NBA championships in 1994 and 1995. Retired players' numbers include CLYDE DREXLER (22), Calvin Murphy (23), Moses Malone (24), HAKEEM OLAJUWON (34) and RUDY TOMJANOVICH (45). The team gave Houston the nicknames CLUTCH CITY and CHOKE CITY.

ROCKET, THE
Nickname for former HOUSTON ASTROS pitcher ROGER CLEMENS.

ROCKIN' ROBIN
Music store specializing in guitars in NEARTOWN, since 1972.

RODEOHOUSTON
New, slicker name for the HOUSTON LIVESTOCK SHOW AND RODEO.

RODEO, THE
The annual HOUSTON LIVESTOCK SHOW AND RODEO, or RODEOHOUSTON, is the largest livestock exhibition in the world and one of Houston's signature events. Typically beginning in March and lasting for twenty days, it first debuted in 1931 as the Houston Fat Stock Show (renamed in 1961). It always includes cowboy competitions, agricultural education competitions, musical acts and a carnival. The Rodeo provides scholarships from its auctions, sponsors and ticket sales. Site of THE COOKOFF.

ROGERS, KENNY
(1938–present)
Native Houstonian, country-western singer/songwriter and actor who grew up in SAN FELIPE COURTS (now Allen Parkway Village) and attended Jefferson Davis High School. His first success was with the First Edition and their psychedelic "Just Dropped In (To See What Condition My Condition Was In)." Went solo in 1976 and had the hits "Lucille," "Coward of the County," "The Gambler," "Lady" and "Islands in the Stream."

ROKRO
Nickname for the RIVER OAKS Kroger on West Gray.

ROPOS
Nickname for the RIVER OAKS police.

ROTHKO CHAPEL, THE
A nondenominational place of worship and contemplation, as well as permanent installation of fourteen site-specific mural canvases by Mark Rothko. Founded by JOHN and DOMINIQUE DE MENIL in 1971, with a program dedicated to peace, freedom and social justice. Designed by Howard Barnstone and Morris Aubry. Barnett Newman's sculpture BROKEN OBELISK sits in the front on a reflecting pool.

ROUGHNECK
Slang for an OIL RIG worker.

RUDY T
Nickname for RUDY TOMJANOVICH.

RUDZ

Nickname for Montrose-area British pub Rudyard's. Named for author Rudyard Kipling (the bar first opened on Kipling Street).

RUNAWAY SCRAPE

The mass flight from family homes by TEXIAN settlers ahead of SANTA ANNA's army in 1836.

RUSHMORE

WES ANDERSON's 1998 movie filmed at his alma mater ST. JOHN'S SCHOOL, as well as at Lamar High School, THE KINKAID SCHOOL, THE HEIGHTS and BOULEVARD OAKS.

RYAN EXPRESS, THE

Nickname for former Houston Astros pitcher NOLAN RYAN.

RYAN, NOLAN

(1947–present)

Baseball Hall of Fame pitcher. Raised in nearby Alvin. Played for the HOUSTON ASTROS from 1980 to 1988, breaking the record for three thousand career strikeouts and pitching his fifth no-hitter. His number, 34, was retired in 1996. Ryan has been special assistant to Astros owner Jim Crane since 2014. His son Reid Ryan was named Astros president in 2013.

Saffir-Simpson Hurricane Scale
Hurricane classification system with five categories to describe storm strength, introduced in 1973.

Saint Arnold
Texas's oldest craft brewery, founded in 1994 by Brock Wagner and Kevin Bartol.

Sakowitz
A former chain of family-owned Houston department stores, founded in 1902 and closed in 1990.

Salsa
Any vegetable-based sauce served in Tex-Mex meals.

Sam Houston Parkway
Nickname for Beltway 8.

Sammy the Owl
The owl mascot of Rice University. Named by a private investigator who found the kidnapped owl at Texas A&M in 1917.

San Felipe Courts
A 1940s public housing project north of Freedmen's Town, built for white defense workers and named for San Felipe Road (which was later renamed West Dallas). Later opened to the adjacent African American community and renamed Allen Parkway Village. Rehabilitated in the 1990s.

"San Fill-uh-pee"
How old-timers and good ol' boys say the street San Felipe. It was once a test for Houston bona fides, but it's much less common lately.

San Jac
Nickname for San Jacinto Community College.

San Jacinto
River in northeast Texas that opens to Galveston Bay. Houston's reservoir Lake Houston was formed on the river in 1953; the San Jacinto

Battleground State Historic Site where the TEXIAN Army was victorious in battle with the Mexican Army, as well as the location of 1936's San Jacinto Monument. Site is in current LA PORTE, Texas.

SAN JACINTO COMMUNITY COLLEGE
Local community college with three campuses. Founded in 1961 in east HARRIS COUNTY. Also known as SAN JAC.

"SAVE YOU MONEY!"
Famous tagline shouted by GALLERY FURNITURE owner/TV pitchman JIM MCINGVALE (MATTRESS MACK).

SCARFACE
(1970–present)
Native Houstonian and hip-hop artist. Joined the GETO BOYS in 1988 and performed on their seminal album *We Can't Be Stopped*.

SCARLET SPIDER
A Marvel Comics character who lives as a fugitive in Houston.

SCHLUMBERGER
The world's largest oil equipment and oil services company, founded in 1920 by the Schlumberger family in France. Schlumberger Well Surveying Corporation was founded in 1935, and the headquarters moved to Houston. DOMINIQUE SCHLUMBERGER DE MENIL is the daughter of co-founder Conrad Schlumberger.

SCHNABEL, JULIAN
(1951–present)
Visual artist and filmmaker, received his Bachelor of Fine Arts degree from UNIVERSITY OF HOUSTON and had his first solo show at the CONTEMPORARY ARTS MUSEUM, HOUSTON, in 1975.

SCREWED IN HOUSTON
Documentary film detailing the influence of the CHOPPED AND SCREWED technique in the Houston hip-hop community, released in 2007.

SCREWPULL
A self-pulling corkscrew by RICE INSTITUTE alumnus and OILMAN Herbert Allen in 1979 in Houston.

Screwston.

Screwston
Houston nickname from fans of local hip-hop act DJ Screw.

"Screw you, Rusty"
Ex-stripper Anna Nicole Smith's exclamation to local defense attorney Rusty Hardin during cross-examination in her court battle for her late husband's fortune.

"Secede"
A proud Texas bumper stick for those who mistakenly think Texas is able to do so. Usually found on vehicles of those unhappy with the president or the federal government.

Secession
Texas seceded from the Union in 1861, joining the Confederate States of America prior to the commencement of the Civil War. Governor Sam Houston sought to prevent Texas secession.

Second Ward
Former political district defined by the corner of Main Street and Congress Street, extending northeast and including the East End and many Mexican-American communities. Established in 1840 as one of the first of the Houston wards. Divided to create the Fifth Ward north of Buffalo Bayou in 1866.

Sesquicentennial Park
Downtown park along Buffalo Bayou commemorating Houston's 150th birthday in 1986, with sculptures by Mel Chin and a promenade underneath the Wortham Theater.

Shadow Lawn
Residential neighborhood developed in 1923. South of Bissonnet and west of Montrose Boulevard. Known for its fourteen large homes along a cul-de-sac. Historic District since 2008.

SHADYSIDE
Small, gated subdivision across Main Street from HERMANN PARK developed by JOSEPH CULLINAN in 1916.

SHAMROCK HOTEL
Built by proud Irish-American WILDCATTER GLENN McCARTHY, adjacent to the young TEXAS MEDICAL CENTER. Hosted Houston's largest party to date at its grand opening in 1949. Known for its ginormous swimming pool, able to accommodate waterskiiers. Sold to Hilton Hotels in 1955. Famously demolished in 1986—one of Houston's first and more painful landmark demolitions.

SHAMROCK SPECIAL
Specialty pizza with corned beef at KENNEALLY'S.

SHARPSTOWN
A master-planned subdivision in southwest Houston developed by Frank Sharp and dedicated in 1955. Home to many ASTRONAUTS in the 1960s.

SHASTA
The name of the UNIVERSITY OF HOUSTON cougar mascot.

SHIP CHANNEL, THE
Houston's ambitious fifty-two-mile, deep-water port connecting Houston via BUFFALO BAYOU and GALVESTON BAY to the world. Congressman TOM BALL proposed the HOUSTON PLAN, whereby Houston and the federal government would share the cost for DREDGING the deep-water channel. JESSE JONES asked Houston banks to accept the bonds to pay for construction, which commenced in 1912. The Ship Channel had been dredged to a depth of twenty-five feet by 1914.

SHIPLEY'S
Chain of "do-nut," coffee and KOLACHE shops founded in Houston by Lawrence Shipley Jr. in 1936.

SHIT-KICKER
Slang for a COWBOY or someone from a rural area. See also KICKER. Also slang for COWBOY boots.

SHO
Abbreviation for the golf tournament Shell Houston Open on the PGA tour, held every spring in HUMBLE. Founded in 1946 at the River Oaks Country Club.

SHOTGUN BUNGALOW
A narrow residence where rooms are connected directly to one another without hallways, with origins in African American communities in New Orleans.

SHRUB
Nickname for George W. Bush given by MOLLY IVINS.

SILVER EAGLE
The nation's largest distributor of Anheuser-Busch products, with headquarters in Houston.

SIXTH WARD
Former political district northwest of Downtown, created out of the FOURTH WARD north of BUFFALO BAYOU in the 1870s. The last ward created, now home to Houston's only Protected Historic District, the OLD SIXTH WARD.

SIZZURP
Nickname for LEAN, a popular illegal drink, purple in color, consisting of Promethazine with codeine, Sprite and candy and usually served in a Styrofoam cup. Originated in Houston. Also known as PURPLE DRANK.

SKILLING, JEFF
(1953–present)
Disgraced former CEO of ENRON, convicted of felony charges related to its fall. Currently incarcerated until 2028.

SLAB
Slang for a car decorated in a flashy hip-hop style, usually with snazzy, protruding rims and a fifth wheel on the trunk, popularized in Houston in the late 1980s.

"SLIME IN THE ICE MACHINE!"
Signature line of consumer advocate TV reporter MARVIN ZINDLER during his on-air rat and roach restaurant reports.

SLIPCOVER
Architectural feature where monolithic materials are attached to the façade of an older building to "modernize" or hide aged materials. Downtown has several high-rises with slipcovers hiding more interesting exteriors.

SLOAN/HALL
An upscale, artsy gift store in RIVER OAKS.

"SMALL ON THE OUTSIDE, BUT BIG ON THE INSIDE"
Quotation from DOMINIQUE DE MENIL describing her MENIL COLLECTION building by RENZO PIANO.

SMARTEST GUYS IN THE ROOM, THE
Shortened name for the documentary film *Enron: The Smartest Guys in the Room* by Alex Gibney, released in 2005 and based on the book of the same name by Bethany McLean and Peter Elkind.

SMITH, ANNA NICOLE
(1967–2007)
Model and actor who was discovered by elderly billionaire and future husband J. Howard Marshall while she was stripping at a Houston strip club.

SMITH, OBEDIENCE
(1771–1847)
Widow pioneer to Texas in 1835. Received a land grant of 4,600 acres from the REPUBLIC OF TEXAS. Her survey ultimately covered more than five square miles and included much of present-day MONTROSE and NEARTOWN.

SMOKING
There has been no smoking in all public places, including bars and restaurants, since 2007, as well as in public parks since 2014.

SOCIAL BOOK, THE
Seasonal calendar for charities' and nonprofit organizations' events. Ultimately, it prevents awkward date/timing conflicts between swanky parties.

SOCIETY FOR THE PERFORMING ARTS
A nonprofit charged with ensuring that JONES HALL is open to alternative performances, operating since 1966. Also known as SPA.

SOUTHAMPTON
A deed-restricted residential neighborhood north of RICE UNIVERSITY designed by architect WILLIAM WARD WATKIN.

SOUTHERN YELLOW PINE
The most common material in home building. During a BOOM, the air is filled with its scent.

SOUTHGATE
A deed-restricted residential neighborhood south of RICE UNIVERSITY and west of THE MEDICAL CENTER.

SOUTHSIDE PLACE
A residential community located south of WEST UNIVERSITY and adjacent to Bellaire Boulevard, founded in 1925. It has resisted annexation by Houston.

SOUTH TEXAS COLLEGE OF LAW
Downtown law school founded in 1923 by the YMCA.

SOUTHWESTERN CONFERENCE
An intercollegiate sports conference from 1914 to 1996, founded in Houston and including charter members Baylor University, Oklahoma State, RICE UNIVERSITY, Southwestern, TEXAS A&M, University of Arkansas, University of Oklahoma and UNIVERSITY OF TEXAS and later adding UNIVERSITY OF HOUSTON, SMU, TCU and Texas Tech.

SOUTHWEST FREEWAY
US 59 southwest of Downtown to Sugar Land.

SOUTHWORST FREEWAY
Mocking nickname for the SOUTHWEST FREEWAY.

SPACE CENTER HOUSTON
The visitor center at JOHNSON SPACE CENTER featuring some space-themed ride and exhibits, as well as plenty of non-space, quasi-science attractions. Opened in 1992.

SPACE CITY
Houston nickname based on the nearby presence of NASA/JOHNSON SPACE CENTER.

SPAIN
Spanish explorer ÁLVAR NÚÑEZ CABEZA DE VACA, who shipwrecked at GALVESTON ISLAND in 1528, was the first European to explore present-day Houston and BUFFALO BAYOU. Fearing that FRANCE would colonize, Spain established missions in East Texas, holding France at the Sabine River. MEXICO won independence from Spain in 1821.

SPANISH INFLUENZA
A major worldwide epidemic that reached Houston in 1918. Also known as the Spanish flu.

SPARK
A nonprofit program to develop public school playgrounds into neighborhood parks. It combines the resources of the Department of Housing and Community Development, seven local school districts, HARRIS COUNTY, the private sector, neighborhood groups, PTA/PTO groups and concerned citizens. Developed by former Houston School Board member and former city council member ELEANOR TINSLEY in 1983.

SPILLOVER
Term describing the increased local activity in the music scene during Austin music festivals, when bands may stop in Houston before or after.

SPINDLETOP
The original Texas BOOMTOWN; the Beaumont salt dome that struck oil in 1901, producing 100,000 barrels per day. The site made Texas a major player in the modern petroleum industry and produced or enlarged companies such as Gulf Oil, TEXACO and HUMBLE. Storage facilities, refineries and oil field equipment companies grew quickly in nearby communities to take advantage of the prosperous oil field.

SPINER, BRENT
(1949–present)
Star Trek actor who attended Bellaire High School and UNIVERSITY OF HOUSTON.

SPRAWL
Term describing Houston's (mostly) unplanned development away from the city center.

SPRING BRANCH
A woodsy community in west Houston, north of the KATY FREEWAY and east of Beltway 8.

SPUR 527
A branch of the SOUTHWEST FREEWAY that cuts through the eastern edge of WESTMORELAND and connects to MIDTOWN at Elgin, since 1961. Also known as the DOWNTOWN SPLIT.

SRIRACHA
Thai hot sauce becoming as ubiquitous to Houstonians as SALSA.

STAGES REPERTORY THEATRE
A small, professional theater founded by Ted Swindley in 1978. Moved to current home in the landmark Star Engraving Building in 1985. It became Houston's second Equity theater in 1988. Also known as Stages.

STAR OF HOPE
Houston's first shelter for homeless men, founded by 1907 by Dennis Pevoto. Now serves women and children.

STATION MUSEUM, THE
A private institution for contemporary art in MIDTOWN, with emphasis on those outside the mainstream art community, founded by JIM HARITHAS and ANN O'CONNOR HARITHAS.

STAUB, JOHN
(1892–1981)
Architect who designed many elegant Houston residences from 1923 to 1963. He is responsible for more than thirty homes in RIVER OAKS, including BAYOU BEND. He also designed the Junior League Building, now BRENNAN'S.

STEAM TUNNELS, THE
Underground, mechanical and utility access tunnels connecting most buildings on RICE UNIVERSITY campus, as well as the site of countless illicit activities.

STERLING, ROSS
(1875–1949)
Governor of Texas, real estate developer and OILMAN who co-founded HUMBLE OIL AND REFINERY COMPANY. Member of the 8-F GROUP.

STEVENSON, BEN
(1936–present)
Former artistic director of HOUSTON BALLET, instrumental in bringing Chinese ballet dancer LI CUNXIN to America, as depicted in *MAO'S LAST DANCER*.

STICK 'EM UP
Documentary film directed by Alex Luster, with Tony Reyes and GONZO247, exploring the subculture of Houston's guerilla street artists, wheat pasters, politicians and law enforcement officials. Released in 2011.

STINKADENA
Mocking nickname for nearby PASADENA, reflecting its refineries' bad smell.

ST. JOE BRICK
A Louisiana wood mold–formed masonry line used extensively throughout the RICE UNIVERSITY campus.

ST. JOHN'S SCHOOL
Coeducational, college preparatory school for kindergarten through twelfth grade, founded in 1946 on the southern edge of RIVER OAKS. No religious affiliation despite sitting adjacent to St. John the Divine Episcopal Church. Two campuses on either side of WESTHEIMER and one west of Buffalo Speedway. Considered the best private school in Houston. Also known as SJS. Famous alumni include MOLLY IVINS, Justise Winslow and WES ANDERSON, who filmed *RUSHMORE* there.

ST. JOSEPH'S HOSPITAL
Houston's first general hospital, opened in Downtown in 1887.

STRIKE OIL
Term for discovering OIL during the act of drilling.

'STROS, THE
Affectionate nickname for the ASTROS.

SUFFERS, THE
A ten-piece GULF COAST soul band with ska, reggae and TEJANO influences, formed in 2011. Made its national TV debut on *The Late Show with David Letterman* in 2015.

SUGAR HILL RECORDING STUDIOS
Recording studio known for such acts as the Big Bopper, LIGHTNIN' HOPKINS, ROY HEAD, Freddy Fender, BEYONCÉ, the Rolling Stones, Little Feat, Lucinda Williams, WILLIE NELSON and MICKEY GILLEY. Founded as Quinn Recording in 1941; then it became GOLD STAR STUDIOS and was renamed Sugar Hill in the 1970s.

SUGAR LAND
A former sugar cane farm and then company town until it was incorporated in 1959. Currently a commuter community southwest of Houston named for the sugar cane crop. IMPERIAL SUGAR was headquartered there after 1907. *Not* the source of "America's Fattest City" jokes.

SUGARLAND EXPRESS
Steven Spielberg's first feature film, shot in SUGAR LAND and released in 1974.

SUITE 8-F GROUP
A collection of politically active Houston bigwigs from the 1940s to the 1960s, including businessmen such as GLENN McCARTHY, ROSS STERLING, GEORGE R. BROWN, GUS WORTHAM, JESSE JONES and ALBERT THOMAS. Named for their meeting place in the Lamar Hotel.

SUMMER CHILLS
The ALLEY THEATRE's summer, discount series of plays, which typically includes a mystery by Agatha Christie.

SUMMER SHAKESPEARE FESTIVAL
Formally the Houston Shakespeare Festival at MILLER OUTDOOR THEATRE, founded in 1975 by SIDNEY BERGER.

SUMMIT, THE
Former sports and concert arena opened in 1976 in GREENWAY PLAZA. Former home to Houston ROCKETS. Renamed COMPAQ Center and then sold to LAKEWOOD CHURCH.

SUNDAY STREETS
Monthly spring/summer festival where a major street is closed to automobile traffic to promote pedestrian awareness. Proposed by *CITE* editor Raj Mankad in 2014.

SUNSHINE KIDS FOUNDATION
Local nonprofit foundation established by Rhonda Tomasco in 1982, providing free events, programs and support for children receiving cancer treatment across North America. CRAIG BIGGIO is its national spokesman. Known for its yellow sun logo.

SURLS, JAMES
(1943–present)
A native East Texas visual artist whose Expressionist sculptures have populated Houston's landscape for decades. Founder of LAWNDALE ART CENTER.

SWAMP
Southwest Alternative Media Project. Founded in 1977 at RICE MEDIA CENTER to promote film/video projects.

SWAMPLOT
Website committed to sharing information, news, gossip and commentary about Houston's real estate market. The authors write anonymously.

SWANKIENDA
From "swanky hacienda," used to describe a fancy home.

SWAYZE, PATRICK
(1952–2009)
Actor, dancer and singer who attended Waltrip High School. Known for roles in movies *The Outsiders*, *Dirty Dancing*, *Roadhouse*, *Point Break* and *Ghost*. Named "Sexiest Man Alive" by *People* magazine in 1991.

SWISHAHOUSE
Hip-hop record label founded by MICHAEL "5000" WATTS and OG Ron C in Houston in 1997.

TAL'S HILL
Landscape feature in MINUTE MAID PARK's center field, featuring a flagpole and named for ASTROS' former general manager and president TAL SMITH, who proposed it.

TANGLEWOOD
A residential neighborhood in west Houston, just outside the LOOP, founded in 1949. PRESIDENT GEORGE H.W. BUSH represented the area in Congress and has owned a home there with his wife, Barbara Bush, since 1994.

TAQUERÍA
Spanish for taco shop, used locally to describe any TEX-MEX restaurant.

TAUB, BEN
(1889–1982)
Real estate developer, philanthropist and advocate for healthcare. BEN TAUB General Hospital was named for him.

TCH
Short for TEXAS CHILDREN'S HOSPITAL.

TDECU STADIUM
UNIVERSITY OF HOUSTON football stadium, opened in 2014.

TEA SIPPER
A demeaning slang name by a student of TEXAS A&M for a student of UNIVERSITY OF TEXAS.

TECHNOLOGY BYTES
A weekly KPFT radio call-in show hosted and founded by Jay Lee and Peter Hughes, addressing computer problems, solutions and news, since 1995.

TEJANO
Spanish for Texan. Typically used to describe a Texan with Mexican ancestry. Also, a type of Mexican-American music originating in the early twentieth century.

TEJAS

Spanish for Texas. Coahuila y Tejas was a former Mexican state established in 1824. It split apart into separate departments before declaring independence from Mexico in 1836. Based on the Caddo word *TEYSHAS*.

TELEGRAPH AND TEXAS REGISTER

The first major newspaper in Texas, founded in 1835 by GAIL BORDEN, Thomas Borden and Joseph Baker in San Felipe. Printed the Constitution of the REPUBLIC OF TEXAS and the original Allen brothers advertisement for the TOWN OF HOUSTON. Moved to Houston in 1837. Ended in 1873. Revived from 1874 to 1877.

TELEPHONE ROAD

Street in South Houston from the EAST END past HOBBY AIRPORT to PEARLAND. Its rowdy, blue-collar reputation was detailed in songs by RODNEY CROWELL and STEVE EARLE.

TENT TICKETS

Coveted entry to the RODEO COOK-OFF—the party inside the party. Sponsored tents provide free BARBECUE, booze and entertainment at the opening of the annual RODEO.

TERMS OF ENDEARMENT

Houston-set novel by LARRY MCMURTRY in 1975, a quasi-sequel to *MOVING ON*; also, a multiple Oscar-winning movie set and filmed in Houston in 1982. Both feature RIVER OAKS and widow AURORA GREENWAY. Jack Nicholson's ASTRONAUT character was added to the movie version.

TERRY HERSHEY PARK

West Houston public park acquired in the 1940s during the building of the ADDICKS RESERVOIR and the BARKER RESERVOIR and developed in 1985 with more than five hundred acres along BUFFALO BAYOU. Named for Buffalo Bayou Preservation Association founder TERRY HERSHEY.

TEX

A nickname for anyone from Texas.

TEXACO

A national oil company founded in 1902 in Beaumont by OILMAN JOSEPH CULLINAN, selling oil from SPINDLETOP. Moved to Houston in 1908, with a new skyscraper headquarters on Rusk & San Jacinto. Also known as the Texas Company.

TEXACO V. PENNZOIL

Lawsuit in which PENNZOIL agreed to acquire Getty Oil in 1984, but Getty took a later offer from TEXACO instead. Pennzoil sued Texaco and won.

TEXAN

Anyone from Texas, or a style of something from Texas.

TEXANS, THE

Houston's National Football League team since 2002. Their home is NRG STADIUM next to the ASTRODOME, and their mascot is a red and blue bull.

TEXAS A&M UNIVERSITY

Texas Agricultural and Mechanical University in COLLEGE STATION, Texas, founded in 1871. Home to the GEORGE H.W. BUSH Presidential Library and Museum. Its mascot is the AGGIE.

TEXAS CHILDREN'S HOSPITAL

A children's and family hospital chartered in the 1940s in the then brand-new TEXAS MEDICAL CENTER.

TEXAS CONTEMPORARY ART FAIR

An annual art fair featuring presentations from seventy galleries showcasing contemporary work from around the world, held at GEORGE R. BROWN CONVENTION CENTER and founded in 2010.

TEXAS DIP

An especially low curtsey by a Texas debutante.

TEXAS EXES

Alumni group of the UNIVERSITY OF TEXAS, with more than fifty thousand in Houston.

TEXAS HEART INSTITUTE, THE
A nonprofit organization founded by DR. DENTON COOLEY in 1962 in the
TEXAS MEDICAL CENTER and affiliated with St. Luke's Episcopal Hospital
and TEXAS CHILDREN'S HOSPITAL. Programs in research, education and
improved patient care seek to reduce cardiovascular disease.

TEXAS MEDICAL CENTER, THE
The world's largest medical district. Founded by M.D. ANDERSON Foundation
trustees in the 1940s. Adjacent to the existing HERMANN HOSPITAL, the
foundation bought more than 134 acres from the city in 1943 for a hospital
district and later convinced existing hospitals, medical schools and healthcare
professionals to relocate there. Home to BAYLOR COLLEGE OF MEDICINE, BEN
TAUB, University of Texas M.D. Anderson Cancer Center, the Methodist
Hospital, TEXAS CHILDREN'S HOSPITAL, the TEXAS HEART INSTITUTE, ST.
LUKE'S EPISCOPAL HOSPITAL, the University of Houston College of Pharmacy,
the Shriner's Hospital for Children and THE MENNINGER CLINIC. Now more
than 675 acres. Also known as THE MED CENTER.

TEXAS MONTHLY
A Texas-centric magazine reporting on politics, leisure, education, travel
and the arts, founded in Houston in 1973 by Michael R. Levy and William
Broyles, now headquartered in Austin.

TEXAS REVOLUTION, THE
The TEXIAN fight for independence from Mexico, from the Battle of Gonzales
in 1935 to BATTLE OF SAN JACINTO in 1836, resulting in the formation of the
REPUBLIC OF TEXAS.

TEXAS ROOM, THE
The public reading room for Houston Public Library's HOUSTON
METROPOLITAN RESEARCH CENTER, which is home to the Texas and Local
History Department, the Archives and Manuscripts Department and the
Special Collections Department and housed in the JULIA IDESON BUILDING.

TEXAS SOUTHERN UNIVERSITY
Originated as an HISD junior college in 1927. Established in 1947 under
the "separate but equal" decision to provide higher education for the African
American community. Located in the THIRD WARD. Formerly the Texas
State University for Negroes. Also known as TSU. Mascot is the TIGERS.

TEXIAN
An Anglo settler in Mexican Texas.

TEXIAN ARMY
The Texas Revolutionary army of soldiers and volunteers; supporters of the HOUSTON DYNAMO soccer team, based on their original name the Houston 1836.

TEXICAN
Another name for TEXIAN. A Texan of Mexican ancestry.

TEX-MEX
Mexican cuisine as served by Texans, possibly coined by MAMA NINFA. Also, how many young Mexican Americans characterize themselves in Texas.

TEXXAS JAM
Pace Concerts' series of rock shows from 1978 to 1988. Helped define contemporary music festivals.

TEYSHAS
Caddo word for friends or allies. Spanish explorers recorded it as TEJAS, source of the name TEXAS.

THEATER DISTRICT
Downtown concentration of performing arts venues, including THE ALLEY THEATRE, JONES HALL, THE WORTHAM CENTER, THE HOBBY CENTER and BAYOU MUSIC CENTER.

"THE VIEW FROM THE WARWICK HOTEL IS THE MOST BEAUTIFUL I'VE EVER SEEN. IT'S JUST LIKE PARIS."
Bob Hope talking about Houston on *The Phil Donahue Show.*

THIRD COAST
Nickname for the GULF COAST.

THIRD WARD
Former political district defined by the corner southeast of Main Street and Congress Street. Established in 1840 as one of the first of the Houston WARDS. Also known as "THE TREY." Home to TSU.

THIS IS OUR HOME, IT IS NOT FOR SALE
A 1987 documentary film by John Schwartz detailing the transition of residential neighborhood RIVERSIDE TERRACE from the 1930s to the 1980s.

THOMAS, ALBERT
(1898–1966)
Congressman from Houston who worked closely with LYNDON JOHNSON in bringing the MANNED SPACECRAFT CENTER to CLEAR LAKE. President Kennedy attended a dinner for Thomas the night before his assassination. BAYOU PLACE was originally a convention center named for him.

THREE BROTHERS BAKERY
A Jewish bakery founded by the Jucker brothers in 1949 in BRAESWOOD PLACE.

THROWED
Slang for drunk or high, or both; also, something cool. Originated in the hip-hop community.

THUNDER SOUL
A 2011 documentary film on the reunion of the famed and funky 1970s-era KASHMERE HIGH SCHOOL STAGE BAND and its tribute concert to CONRAD "PROF" JOHNSON.

THURGOOD
Nickname for the TEXAS SOUTHERN UNIVERSITY Thurgood Marshall School of Law.

TIGERS, THE
Name for the athletic teams of TEXAS SOUTHERN UNIVERSITY.

"TIGHTEN UP"
Soulful, early funk, number one song by ARCHIE BELL & THE DRELLS whose lyrics name-check Houston.

TINSLEY, ELEANOR
(1927–2009)
A fierce Houston city councilwoman, famous for sticking her neck out for local causes, including public school integration, water fluoridation, billboard

removal and indoor smoking. Founder of the SPARK program. A park on ALLEN PARKWAY was named in her honor in 1998.

TIRR
The Institute for Rehabilitation and Research. Founded the TEXAS MEDICAL CENTER in 1959 as the Texas Institute for Rehabilitation and Research. Currently ranked as one of the top five rehab hospitals in the nation.

TIRZ
Tax Increment Reinvestment Zone. A city-designated area where property taxes are frozen, creating a more inviting climate for investing and potentially spurring community development. As develop occurs, raising property values, any tax revenues above the pre-TIRZ level are directed back to the area to finance public improvements within the boundaries of the zone.

TMSL
Abbreviation for the TEXAS SOUTHERN UNIVERSITY Thurgood Marshall School of Law.

TOADSTOOL TOWNHOUSE
Nickname for the cheap and fast residences that populate Houston and appear seemingly overnight.

TOLERANCE SCULPTURES
Art installation by Jaume Plensa of large, seated figures on ALLEN PARKWAY at Montrose Boulevard, dedicated in 2011 to Houston's diverse community.

TOMBALL
Community north of Houston named for U.S. Representative TOM BALL.

TOMBALL PARKWAY
State Highway 249.

TOMJANOVICH, RUDY
(1948–present)
Former player and former head coach of the HOUSTON ROCKETS. Famously took a life-threatening PUNCH on the basketball court in 1977. Led the Rockets to back-to-back NBA championships in 1994 and 1995. Also known as RUDY T.

TONY'S
Fine dining Italian restaurant built and run by Tony Vallone since 1965. Among Houston's most famous restaurants.

TOOTSIE
Nickname for Mayor KATHY WHITMIRE from her early-career resemblance to the Dustin Hoffman movie character, circa 1983.

TORO
The bull mascot of the TEXANS football team.

TOUR DE HOUSTON
Annual fundraising bike ride hosted by the Mayor's Office of Special Events, founded in 2005.

TOWER THEATER
A former movie theater, opened in 1936 on LOWER WESTHEIMER. Converted to the performing arts venue in 1978. The interior was demolished in the 1990s to make way for retail. Current home of El Real restaurant.

"TOWN OF HOUSTON"
Headline in the *TELEGRAPH AND TEXAS REGISTER* announcing THE ALLEN BROTHERS' new real estate venture upstream from HARRISBURG; named for the hero of the BATTLE OF SAN JACINTO, SAM HOUSTON.

TOY CANNON
Nickname for COLT .45 and ASTRO Jimmy Wynn, whose number, 24, was retired in 2005.

TOYOTA CENTER
Sports and entertainment venue in Downtown. Home to the Houston ROCKETS. Opened in 2003. Features a sculptural rendering of HAKEEM OLAJUWON's jersey in the entry plaza.

TRAFFIC
Houston is famous for its FREEWAY congestion, due in large part to SPRAWL.

TRAIL RIDE
Since 1952, various groups of professional and amateur horseback riders converge on MEMORIAL PARK in the days leading up to the opening of

Transco Tower/
Williams Tower.

the Houston Livestock Show and Rodeo. Always very festive.

TRANQUILITY PARK
Downtown city park named for the lunar landing site of APOLLO 11.

TRANSCO/TRANSCO TOWER
The signature GALLERIA skyscraper by GERALD HINES and designed by PHILIP JOHNSON and John Burgee, opened in 1983; currently named Williams Tower. One of Houston's signature landmarks. Known for its solitary height and rotating nighttime searchlight that some have claimed made the tower look like a giant aerosol can fumigating the city.

TRANSCO FOUNTAIN
Also known as the WATERWALL. Massive 180-degree fountain and park adjacent to TRANSCO built in 1985. Site of countless engagement and QUINCEAÑERA photos. The City of Houston bought it and renamed it GERALD D. HINES Waterwall Park in 2008.

"TREAT HER RIGHT"
A soulful number one song by ROY HEAD in 1965, recorded at GOLD STAR RECORDS.

TREATIES OF VELASCO
(May 14, 1836)
Documents signed following the BATTLE OF SAN JACINTO ending hostilities between Texas and Mexico—SANTA ANNA kept his life in return for Mexico retreating to the Rio Grande. Two separate sets, one public and one private, were never ratified by Mexico, which hoped to re-invade Texas. Later the public basis for President James Polk's Mexican-American War.

TREEBEARD'S
Famous southern-style lunch restaurant and event space with locations in MARKET SQUARE, Christ Church Cathedral, the Shops at Houston Center and the TUNNELS.

TREE OF LIFE
The 2011 Terrance Malick film shot in Houston and Smithville.

TREE ROACH
The Texas-sized cockroach, known for flying and chasing Houstonians once disturbed.

TREES FOR HOUSTON
Nonprofit founded in 1982 by Bill Coats and Carroll Shaddock as the Live Oak Society, later expanded to plant, protect and promote all of Houston's urban forest.

TREY, THE
Nickname for the THIRD WARD. Also "Trae" and "Tre."

TRILL
Slang for being true and real. Popularized by the hip-hop community in Port Arthur, Texas, and mostly associated with BUN B.

TROSE/TROSE, THE
Nickname for MONTROSE.

TSU
Short for TEXAS SOUTHERN UNIVERSITY.

TUMP
Slang for knocking over something, as in, "He *tumped* his coke on the floor."

TUNE, TOMMY
(1939–present)
Tony-winning actor, choreographer and director who attended Lamar High School. The Tommy Tune awards are presented by TUTS to honor excellence in Houston high school musical theater.

TUNNELS, THE
A series of connected of pedestrian tunnels, with retail and dining, linking many Downtown Houston buildings. The courthouse has its own separate tunnel system spanning BUFFALO BAYOU.

TURNING BASIN, THE
A multipurpose complex of wharves at the navigational head of THE SHIP CHANNEL, equipped to load or unload any type of break-bulk, container, heavy-lift cargoes or vehicle.

TURRELL, JAMES
(1943–present)
Visual artist who created the *Skyspaces* ceiling opening in the Live Oaks Friends Meeting House and a light sculpture for the MFAH tunnel, as well as designed the TWILIGHT EPIPHANY pavilion at RICE UNIVERSITY.

TUTS
Theater Under the Stars. A performing arts organization dedicated to producing and hosting live musical theater, as well as education and outreach. Founded in 1968. The first shows were at MILLER OUTDOOR THEATRE and, later, in the HOBBY CENTER. TUTS founded the TOMMY TUNE Awards in 2003 to honor excellence in Houston high school musical theater.

TWILIGHT EPIPHANY
Outdoor skyspace pavilion with large, square canopy featuring a center void to frame the sky, designed by JAMES TURRELL. Opened in 2012 at RICE UNIVERSITY.

TWIN TOWERS
Nickname for THE HOUSTON ROCKETS' Ralph Sampson and HAKEEM OLAJUWON in the mid-1980s.

TWOMBLY GALLERY
A visual arts gallery on the MENIL COLLECTION campus dedicated exclusively to the artist Cy Twombly. Designed by RENZO PIANO and opened in 1995.

TWO STAR SYMPHONY
A modern classical/experimental string quartet founded in 2003.

TWO-STEPPING
A dance move popular in county-western music with a quick-quick-slow-slow rhythm. Also known as the Texas Two Step.

UGK
Abbreviation for UNDERGROUND KINGZ.

UH
Shortened version of UNIVERSITY OF HOUSTON. Also, U of H.

UHD
Shortened version of UNIVERSITY OF HOUSTON–DOWNTOWN.

"UMBLE"
Local pronunciation of HUMBLE, Texas, northeast of Houston.

UNCLE CHARLIE
Pseudonym for Charlie Hardwick, a visual artist known for painting and printing vibrant gig posters. Legally blind since 2007.

UNDERGROUND KINGZ
Local hip-hop duo of BUN B and PIMP C from 1987 to 2007. Also known as UGK.

UNDERTAKER, THE
(1965–present)
Native Houstonian and professional wrestler who attended Waltrip High School.

UNIVERSITY LINE
The still-in-limbo METRORAIL line that will connect UH, TSU, MONTROSE, UST, GREENWAY PLAZA AND the northern edge of WEST U to the proposed Gold Line at THE GALLERIA, running down Richmond Avenue and Westpark. There appears to be no support from the federal government, but METRO may still fund it itself.

UNIVERSITY OAKS
A modest residential neighborhood adjacent to UNIVERSITY OF HOUSTON and BRAYS BAYOU. Known for its UH professors and students.

UNIVERSITY OF HOUSTON
A public university founded in 1927 by HISD as a junior college. Became a four-year school in 1934. Moved to its current campus in 1939 on land donated by Julius Settegast and BEN TAUB. The University of Houston System includes UH–Clear Lake, UH–Downtown, UH–Victoria, UH–Sugar Land and UH–Cinco Ranch. Home to KUHF and KUHA. Third-largest public university in Texas. Rated a Tier One research university by the Carnegie Foundation in 2011. Home to the COUGARS.

UNIVERSITY OF HOUSTON–DOWNTOWN
Founded in 1974 out of the former South Texas Junior College at the foot of Main Street. Currently struggling with finding a new name.

UNIVERSITY OF ST. THOMAS
Private Catholic institute of higher learning founded by the Basilian Fathers in 1947 in MONTROSE, adjacent to the MENIL COLLECTION campus, and named for St. Thomas Aquinas. John and Dominique de Menil invited PHILIP JOHNSON to design the campus master plan 1950s, and he returned to design the gold-domed Chapel of St. Basil in 1997.

UNIVERSITY OF TEXAS
Public institute of higher learning founded by the State of Texas in 1883 in Austin. Houston is home to the highest number of UT alumni, the TEXAS EXES, with more than fifty thousand.

UNIVERSITY PARK
The former name of UH Central Campus, from 1983 to 1991.

UPPER KIRBY
A coalition of businesses on or adjacent to Kirby Drive near the SOUTHWEST FREEWAY, created in 1996 to improve the image through beautification projects and identified by red street signs.

UPSTREAM
The division of the OIL AND GAS industry dedicated to exploration and production of CRUDE OIL or NATURAL GAS.

UPTOWN
GALLERIA area neighborhood. Formally known as UPTOWN PARK.

URBAN ANIMALS
Group of roller skaters founded in 1979 and known for its large, moving mass of wheeled barhoppers in Downtown and MONTROSE. Lately, they are harder to spot.

URBAN COWBOY
Movie set in the refineries of PASADENA and the famed honky-tonk GILLEY'S, released in 1980. It both captured and generated country-western trends. Based on a 1978 magazine article by Aaron Latham.

URBAN HARVEST
An organization that promotes healthy communities, sound nutrition and respect for the environment through education, as well as facilitates harvest and habitat gardens. Hosts farmers' markets Downtown and on Eastside Street.

UST
Shortened version of UNIVERSITY OF ST. THOMAS.

UT
Shortened version of UNIVERSITY OF TEXAS.

UTMB
Shortened version of UNIVERSITY OF TEXAS Medical Branch at Galveston. The state's first medical school, founded in 1891, when Galveston was larger than Houston. It joined the MEDICAL CENTER in 2010.

VALENTI, JACK
(1921–2007)
Native Houstonian and assistant to PRESIDENT LYNDON JOHNSON. He attended the UNIVERSITY OF HOUSTON, where the School of Communication bears his name. As the founder and president of the Motion Picture Association of America, he created the movie rating system.

VALHALLA
Graduate student dive bar on RICE UNIVERSITY campus, famous for cheap beer.

VALLEY, THE
Short for the Rio Grande Valley.

VAN ZANDT, TOWNES
(1944–1997)
Singer/songwriter who lived for a short time in Houston and famously struggled with alcoholism and drugs. He recorded *Live at the Old Quarter, Houston, Texas* in 1973.

VILLAGE, THE
Shopping center RICE VILLAGE, founded in the 1940s between RICE UNIVERSITY and WEST UNIVERSITY. Various landlords include RICE UNIVERSITY, WEINGARTEN and Olson Brothers.

VINEGAR HILL
Former notorious Downtown slum, near the current post office; chronicled in *Sig Byrd's Houston.*

VOICES BREAKING BOUNDARIES
Nonprofit arts organization founded in 2000 and dedicated to performing literary works, presenting visual art and hosting speakers with an emphasis on social justice, women's rights, race and education.

WALGREEN'S SEASONAL INTERVENTION
In a city where seasons are hard to discern, these retail store holiday decorations let Houstonians know exactly what is the current season.

WALLISVILLE ROAD
A street in northeast Houston; a song by native LYLE LOVETT.

WALL, PAUL
(1981–present)
Houston hip-hop artist who attended Jersey Village High School.

WARD
Former political district/governing system established in 1840. Each of Houston's six wards had two elected aldermen to serve on the city council. Abolished in 1915 but still used by some in name only.

WARDROBE MALFUNCTION
When Houston hosted Super Bowl XXXVIII in 2003, Justin Timberlake, while assisting Janet Jackson, exposed her breast for a split second during the halftime show. The phrase was coined by them when they were asked to apologize.

WARWICK HOTEL
Former old-school, upscale hotel in the MUSEUM DISTRICT since 1926. Transformed into the Dallas-based luxury boutique Hotel ZaZa in 2007.

WASH AVE.
Nickname for WASHINGTON AVENUE and the surrounding neighborhoods and businesses.

WASHBURN TUNNEL
Connection under THE SHIP CHANNEL of Federal Road on the north shore to PASADENA, completed in 1950. It is the only underwater tunnel in Texas.

WASHINGTON AVENUE
A major east–west road connecting Downtown to the WEST END. Known for years for its blue-collar businesses, including used car lots, TAQUERIAS and

the impressive GLENWOOD CEMETERY. It was transformed into an unplanned entertainment district with mostly noisy BRO BARS and velvet rope clubs, but that trend might be fading due to Downtown's resurgent bar scene.

WASHINGTON CORRIDOR
A more polished nickname for WASHINGTON AVENUE, usually employed by planners, architects and politicians.

WASHINGTON SHORE
A nickname for WASHINGTON AVENUE reflecting its cheesiness, a play on the name "Jersey Shore."

"WATER-BURGER"
Local pronunciation of fast-food chain Whataburger.

WATERWALL, THE
Also known as TRANSCO FOUNTAIN. A massive 180-degree fountain and park adjacent to TRANSCO built in 1985. Site of countless engagement and QUINCEAÑERA photos. The City of Houston bought it and renamed it GERALD D. HINES Waterwall Park in 2008.

WATKINS, WILLIAM WARD
(1886–1952)
Architect who laid out SOUTHAMPTON and BROADACRES, designed the original MFAH and the AUTRY HOUSE, oversaw construction of the first buildings at RICE INSTITUTE and led its architecture department until 1952.

Waugh Bat Bridge.

WATTS, MICHAEL "5000"
Houston-based hip-hop DJ known for his CHOPPED AND SCREWED SWISHAHOUSE remixes that hit big in 2004.

WAUGH BRIDGE BAT COLONY
Home to nearly 300,000 Mexican free-tailed bats at the corner of Waugh and ALLEN PARKWAY. A viewing deck was installed in 2006.

WAUGH CRACK

The bicycle hazard running along the center of Waugh Drive just north of Memorial Drive. An expansion joint filled with asphaltic polyurethane sealant where bike wheels frequently get stuck.

WEATHER PORN

The indulgent activity of making or watching televised hurricane reports that do not change quickly but instead repeat. Are meant to excite or frighten the public into fleeing or nonstop viewing. Typical examples include reporters standing in blowing wind and rain or the line, "The storm is racing toward us."

"WE CHOOSE TO GO TO THE MOON…AND DO THE OTHER THINGS, NOT BECAUSE THEY ARE EASY, BUT BECAUSE THEY ARE HARD."

Inspirational quotation delivered in a speech by President Kennedy at RICE STADIUM on September 12, 1962, as a part of his New Frontier program that included being the first nation on the moon.

WEED EATER

A gardening product invented by Houstonian George Ballas in 1972.

WEINGARTEN

A former family grocery business and chain of stores. Now a national realty company that demolished the Village Theater, scrapped the Art Deco interior of the ALABAMA THEATRE, altered the historic River Oaks Shopping Center and continues to leave the landmark River Oaks Theatre unprotected.

WEST ALABAMA ICE HOUSE

Former neighborhood grocery store founded in 1927 in NEARTOWN. Currently a popular outdoor bar known for picnic tables, crawfish boils and all types of beer drinkers.

West Alabama Ice House.

WEST AVE.
An upscale commercial and residential mixed-use development at the corner of Westheimer and Kirby.

WESTBURY
A late 1950s and early 1960s subdivision in southwest Houston, south of BRAYS BAYOU.

WEST 11TH PLACE
Upscale residential neighborhood. South of Bissonnet and west of Montrose Boulevard. Known for its large, early twentieth-century homes and private street. Listed on the National Register of Historic Places. HISTORIC DISTRICT since 1997.

WESTFEST
Nickname for WESTHEIMER STREET FESTIVAL.

WESTHEIMER
Family shipping company founded by Michael Louis Westheimer, who once owned a farm on what is now Westheimer Street past KIRBY, from Bellaire Boulevard north to current-day RIVER OAKS; one of Houston's longest streets, from Montrose to the Katy Prairie. HARRIS COUNTY named the street Westheimer in 1895.

WESTHEIMER STREET FESTIVAL
Biannual community street fair on LOWER WESTHEIMER from 1971 to 1999, known for people watching, live bands and partying. Newer, more conservative MONTROSE residents killed it.

WESTMORELAND
South End Land Company platted the Westmoreland Addition in 1902 as a streetcar suburb. North of West Alabama, east of Montrose Boulevard and west of SPUR 527. Known for its late-Victorian and early twentieth-century homes. In spite of lapsed DEED RESTRICTIONS, the subsequent encroachment of non-contributing structures such as garden apartments and the imposition of Spur 527 at the western entrance, Westmoreland is listed on the National Register of Historic Places. LYNDON JOHNSON lived there in the 1930s when he taught school. HISTORIC DISTRICT since 1997.

WEST TEXAS INTERMEDIATE
A type of CRUDE OIL used in gauging general oil prices per barrel. Both professional and amateur economists use this to measure Houston's financial stability, with higher prices considered good for Houston's economic health.

WEST U
Nickname for WEST UNIVERSITY PLACE.

WEST UNIVERSITY PLACE
An independent municipality founded west of Kirby in 1925 that stubbornly resists ANNEXATION by Houston. Once known for modest homes where RICE INSTITUTE professors could raise a family, now overrun with McMANSIONS too large for their sites. Identified by its blue street signs.

WHAM
Winter Holiday Art Market. An annual juried selection of arts and crafts and performances, hosted by SPACETAKER, now FRESHARTS, since 2006.

"WHAT USED TO BE THERE?"
Common query reflecting Houston's lack of preservation, which engenders local AMNESIA and increased DEMOLITION.

WHEN WE RULED H-TOWN
A 2012 documentary film recalling Houston's music scene in the 1990s, with an emphasis on metal and punk bands.

"WHERE 17 RAILROADS MEET THE SEA"
Coined by the Houston Chamber of Commerce promoting one of Houston's major features in the early twentieth century.

"WHERE'S THE MOUSE?"
What every child is thinking or saying during Houston Ballet's annual performances of *The Nutcracker*.

"WHISKEY RIVER"
Country-western song by native Houstonian JOHNNY BUSH but known worldwide as a signature WILLIE NELSON song.

WHITE OAK BAYOU
A waterway originating in northwest Houston, flowing south of the HEIGHTS and merging with BUFFALO BAYOU at ALLEN'S LANDING in DOWNTOWN. The bayou is channelized from SPRING BRANCH to Downtown.

WHITMIRE, KATHY
(1946–present)
Five-term Houston mayor, from 1982 to 1992. The first woman to hold the office. She was famously teased in the early 1980s for her resemblance to the movie character TOOTSIE.

WILDCATTER
Slang for an OIL RIG or oil field worker.

WILDCATTER BOURBON
Glenn McCarthy's whiskey label.

WILLIE D
(1966–present)
Native Houstonian, hip-hop MC, member of GETO BOYS since 1988 and community activist. He co-wrote the landmark hip-hop song "MIND PLAYING TRICKS ON ME."

WILLOW STREET PUMP STATION
Houston's former first wastewater treatment facility, built in 1902 at the confluence of BUFFALO BAYOU and WHITE OAK BAYOU. The restored Downtown landmark is now a community space owned by UNIVERSITY OF HOUSTON–DOWNTOWN since 2003.

WILLY
Current nickname for WILLIAM MARSH RICE, founder of RICE UNIVERSITY. Also, the nickname for the statue of William Marsh Rice.

WILLY WEEK
The week preceding BEER BIKE at RICE UNIVERSITY, when residential college JACKS are commonplace.

WILSON, CHANDRA
(1969–present)
Actor and director who attended HSPVA, known for role on TV show
Grey's Anatomy.

WILSON, ROBERT WOODROW
(1936–present)
Native Houstonian who attended Lamar High School and was a RICE
UNIVERSITY alumnus. Won the Nobel Prize in physics in 1978.

WINGER, DEBRA
(1955–present)
Actor who starred in two Houston movies, *URBAN COWBOY* and *TERMS OF
ENDEARMENT*.

WINTER
Season that barely applies to Houston.

WOODLAND HEIGHTS
A residential neighborhood east of THE HEIGHTS. Designated as a HISTORIC
DISTRICT in 2011.

WOODLANDS, THE
A woodsy master-planned community north of Houston developed by
GEORGE MITCHELL in 1974. The community has successfully resisted
ANNEXATION by Houston.

WORLD ECONOMIC SUMMIT
A July 1990 meeting of world leaders including the United States, Canada,
France, Italy, Japan, United Kingdom, West Germany and the European
Commission. Hosted by PRESIDENT GEORGE H.W. BUSH at RICE UNIVERSITY
and MFAH. Also known as the G7.

WORLDFEST
Founded in 1961 as Cinema Arts, an international film festival. Now an
annual spring film competition, the third-oldest in North America, run by
Hunter Todd since 1968.

WORTHAM, GUS S.
(1891–1976)
Native Houstonian and philanthropist founder of AMERICAN GENERAL CORPORATION. THE DANDELION FOUNTAIN is named in his honor.

WORTHAM, THE
The GUS S. WORTHAM Theater Center. Built as a permanent home for the Houston Ballet and HGO in 1987. It has two theaters, spans two city blocks and is above adjacent SESQUICENTENNIAL PARK and BUFFALO BAYOU.

WYATT, LYNN
(1935–present)
Native Houstonian, philanthropist, socialite and Houston ambassador. Granddaughter of the SAKOWITZ department store founder.

Y'ALL

Slang for the plural tense of "you" and short for "you all." Typically, the first lingo learned and used by a NEWSTONIAN, sometimes begrudgingly.

YATES, REVEREND JACK
(1828–1897)

Formerly enslaved man who moved to Houston in 1865 following emancipation and became a Baptist preacher. As the first pastor of ANTIOCH MISSIONARY BAPTIST CHURCH, he led the effort to purchase EMANCIPATION PARK in 1872 and was an early homeowner in FREEDMEN'S TOWN. Jack Yates High School is named for him.

YO-PRO

Short for young professional. Typically used in young professional groups. See YP.

"YOU-STON"

Acceptable local pronunciation of Houston.

YP

Short for young professional. Houston has countless YP groups.

ZAPATA PETROLEUM COMPANY

Formerly the Zapata Oil Company, founded by GEORGE H.W. BUSH and partners in 1953. Merged with South Penn Oil to become PENNZOIL in 1963.

ZELLWEGGER, RENÉE

(1969–present)

Academy Award–winning actor, born and raised in KATY.

ZINDLER, MARVIN

(1921–2007)

Television personality and consumer advocate reporter. Exposed the LA GRANGE Chicken Ranch brothel. Known for his white suit, blue-lensed glasses, cosmetic surgery and signature line, "SLIME IN THE ICE MACHINE," which he delivered with gusto during his rat and roach restaurant reports.

ZONING

Houston is famous for its lack of this, allowing for its wild, disorganized and unpredictable look. Voters rejected zoning in 1948, 1962 and in 1993. The City of Houston uses MINIMUM LOT SIZE AREA as a de facto zoning tool.

Z-WORD, THE

How politicians refer to occasionally unpopular and occasionally popular ZONING.

ZZ TOP

Bluesy rock band founded in Houston in 1969 by BILLY GIBBONS, with Frank Beard and Dusty Hill filling out the classic lineup shortly thereafter. Their debut album dropped in 1971. Inducted into the Rock and Roll Hall of Fame in 2004. Wrote the song "LA GRANGE" about the famed brothel the Chicken Ranch.

ZZ Top.

NUMBERS, FIGURES, DIGITS AND DATES

2
Land speculator brothers AUGUSTUS ALLEN and JOHN KIRBY ALLEN, from New York, who founded Houston in 1836.

2:00 A.M.
The time the bars close.

4
Houston is the fourth-largest city in the United States.

5°
The lowest recorded temperature in Houston, on January 23, 1940.

6
The number of WARDS before they were abolished in 1915.

6:00 P.M.
The time free parking starts Downtown from Monday through Saturday.

8.25
The percent sales tax, a combination of 6.25 state tax and 2.00 local tax.

10'
The gap between the two towers of PENNZOIL PLACE.

12ᵀᴴ MAN
Fans of AGGIE football.

14 PEWS
The nonprofit film organization and venue in a converted East Sunset Heights church, founded by Cressandra Thibodeaux in 2010.

17
The number of railroads that the chamber of commerce claimed met in Houston.

18 MINUTES
The time it took SAM HOUSTON and the TEXIAN ARMY to defeat SANTA ANNA at the decisive BATTLE OF SAN JACINTO.

23'
The elevation of the HEIGHTS above Downtown.

29°, 95°
The latitude and longitude of Houston, Texas. Former *HOUSTON CHRONICLE* entertainment insert magazine on Thursdays.

No. 34.

34
The legendary jersey number retired by the ASTROS for NOLAN RYAN, by the ROCKETS for HAKEEM OLAJUWON and by the OILERS for EARL CAMPBELL.

41
The nickname for Houston OILMAN and congressman GEORGE H.W. BUSH, who was the forty-first president of the United States.

APPENDIX

50'
The average elevation in feet above sea level for Houston.

52 MILES
The length of THE SHIP CHANNEL.

90-DAY WAIVER
A meaningless deterrent to DEMOLITION of a historic structure outside a HISTORIC DISTRICT. If the HAHC rejects a proposed alteration or demolition by denying a CERTIFICATE OF APPROPRIATENESS, then the applicant will receive a 90-day waiver, allowing the alteration or demolition to proceed after waiting such time.

109°
The highest recorded temperature in Houston, on September 4, 2000.

281
Houston's second area code, active since 1997. Because it was first assigned to areas outside Beltway 8, it was less desirable for INNER LOOPER cellphone numbers.

300
Also "THE OLD THREE HUNDRED." Pioneer families who joined land EMPRESARIO STEPHEN F. AUSTIN in the first legal settlement of Mexican-ruled Texas.

346
Houston's fourth area code, which debuted in 2014 and overlaid the existing area codes.

610
Interstate 610. See also THE LOOP.

~634
The square miles that the city of Houston covers.

713
Houston's first area code. Typically the most desirable number for INNER LOOPER cellphone numbers.

770 - -
Houston-area zip code prefix.

832
Houston's third area code. Active since 1999, when area codes lost their geographic assignments and ten-digit dialing went into effect.

1836
The year of Houston's founding, when the ALLEN BROTHERS posted an advertisement in the *TELEGRAPH AND TEXAS REGISTER*. Widely considered to be the city of Houston's actual birthday, rather than 1837, when Houston was incorporated.

1900
The year of GALVESTON's catastrophic HURRICANE, which led the way for Houston's surge to dominance as the largest city in Texas.

1901
The year OIL was discovered at SPINDLETOP, leading to more found in Beaumont and Goose Creek and the development of Houston as the region's leader in oil refineries.

1954
The year in which Houston got its one-millionth citizen.

3,060
The number of hits HOUSTON ASTRO CRAIG BIGGIO had in his professional baseball career.

6,642
Acreage bought by the ALLEN BROTHERS that would become the first portion of the city of Houston.

ABOUT THE AUTHOR

James Glassman is the founder of Houston's loudest preservation group, Houstorian, dedicated to telling the story of Houston. A fifth-generation Houstonian, Glassman works in Houston as an architectural project manager. He has a Bachelor of Arts in history from Kenyon College and a Master of Architecture from the University of Houston. In 2013, Glassman was honored by the *Houston Press* as one of its "100 Creatives" and by the *Houston Chronicle* as one of 2013's Most Fascinating People. He won Tweet of the Year at the 2013 Houston Press Web Awards. Glassman has also been recognized for his advocacy of the Astrodome,

Photo by Julie Soefer.

with quotes in the *New York Times*, the *Guardian* and the *Atlantic Monthly*. Wear Houston, his Houston-inspired graphic designs, have been featured in *Houstonia Magazine*, the *Houston Chronicle*, the *Houston Press* and *CultureMap*.

Visit us at
www.historypress.net

This title is also available as an e-book